POSTER COLLECTION

SCHWARZ UND WEISS
BLACK AND WHITE

08

Mit einem Essay von / Essay by Lars Müller

MUSEUM FÜR GESTALTUNG ZÜRICH
PLAKATSAMMLUNG / POSTER COLLECTION

LARS MÜLLER PUBLISHERS

RICHARD III

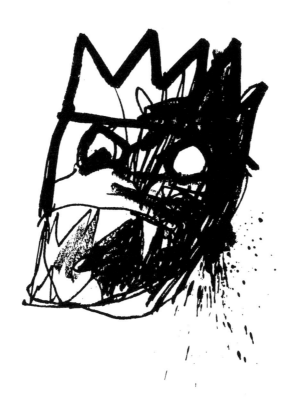

1 **James Victore**
Richard III
1994

Jeder Ort hat sein eigenes Kolorit. Ein Gang durch die Stadt hat es mir bestätigt. Die Signale, Leitsysteme, Leuchtschriften und Werbeflächen verschaffen der Stadt ihr Farbklima. Und doch muss ich eingestehen, dass die Unterschiede zu anderen Städten immer schwieriger zu benennen werden. Wie alle anderen Medien scheinen auch Plakate in der Anmutungsqualität ihrer Farben ein Ideal anzustreben, wo reproduzierte und reale Farbe austauschbar werden. Ein Rückblick auf die Ästhetik der Massenkultur macht das verständlich: Seit jeher wurde Wohlstand und gute Laune mit Farbigkeit gedeutet. Der allgemeinen Buntheit der politischen, kommerziellen und kulturellen Werbung liegt der Anspruch zu Grunde, wenn nicht dem Blick Vergnügen zu bereiten, so doch positive Affekte auszulösen. Und mit der gleichen Anmassung, mit der die Werbung bildhaft vorwegnimmt, was sie für unsere Träume hält, bedient sie sich aller Ressourcen, die ihre Medien zur Verfügung stellen – auch in bezug auf die Farbe.

Der positive Subtext der Farbe wird unterstützt durch die Fortschritte der Drucktechnologie. Je grösser die Brillanz und Dichte eines Plakats, je «authentischer» die fotografische Wiedergabe, je kleiner die Fehlleistung gegenüber den Farben, desto deutlicher suggeriert die Bildproduktion unseren verwöhnten Augen Status und Verfügbarkeit. Doch umgekehrt wird durch die idealtypische Annäherung des Drucks an die reale Welt seine gestalterische und technische Bedingtheit ausgeblendet: Hier wie in vielen anderen Bereichen der visuellen Kultur werden die Deutungen der Welt durch technische Möglichkeiten geprägt und die Interpretationen an die industriellen Verfahren delegiert. Die Meinung, dass Farbe einfach «geschieht», ohne Anstrengung und ohne Entscheidung, ist eine Folge ihrer medialen Profanisierung. Wegen ihrem flächendeckenden Einsatz wird die Farbe ihrer Wirkung beraubt und verbreitet sich wie ein visuelles Narkotikum. Weil sie wie selbstverständlich scheint, schlafft sie als Code der visuellen Kommunikation ab. Schon 1949 schrieb Paul Rand: «Many advertisers and advertising artists feel that an advertisement becomes more colorful in proportion to the amount of color used in it. This is often untrue.» Wenig später hat der Kolorist Armin Hofmann seine schwarz-weissen Plakate damit begründet, dass die farbliche Subtilität, die er sich gewünscht hätte, in der Geschwätzigkeit des öffentlichen Raums wirkungslos geblieben wäre.

Welcher Motivation oder Haltung die Plakate in dieser Zusammenstellung auch entstammen – sie demonstrieren plausibel, dass mit der Entscheidung für das System «Schwarz und Weiss» der Gestaltung ihre Macht und der Farbe ihre Dringlichkeit zurückgegeben werden kann.

Felix Studinka

FOREWORD

Every location has its own colouring. Walking through town confirmed this for me. Signals, traffic signs, neon lights and advertisements determine the city's colour climate. And yet I must admit that it is becoming increasingly difficult to say why this city is any different from other cities. Like all other media, posters seem to be using the attractive quality of their colours to take them into an ideal state in which reproduced and real colour are interchangeable. A glance back at the aesthetic of mass culture explains this: colour has conveyed affluence and good spirits from time immemorial. The generally colourful quality of political, commercial and cultural advertising is based on the claim that if it is not possible to give pleasure to the eye, then at least positive emotions should be generated. And the same presumption that drives advertising to anticipate pictorially what it considers to be our dreams impels it to exploit every resource its media offer – and this includes colour.

The positive subtext of colour is supported by the progress that has been made in printing technology. The greater the brilliance and density of a poster are, the more "authentic" the photographic reproduction, the fewer lapses there are in reproducing colours, the more clearly the image produced will suggest status and availability to our pampered eyes. But conversely, printing's ideal-typical approach to the real world takes no account of the medium's creative and technical limitations: here, as in many other spheres of visual culture, interpretations of the world are shaped by technical possibilities and interpretation is delegated to industrial processes. The view that colour simply "happens", without any sort of effort or decision, is a consequence of its secularization by the media. It is used absolutely everywhere, so colour is robbed of its effectiveness and proliferates like a visual narcotic. Because its presence is taken for granted, it is losing its impact as a visual communication code. Paul Rand wrote as early as 1949: "Many advertisers and advertising artists feel that an advertisement becomes more colorful in proportion to the amount of color used in it. This is often untrue." A little later the colourist Armin Hofmann justified his black-and-white posters on the grounds that the subtle colours he would have liked to explore would have made no effect amid the clamour of public space.

Whatever motivation or approach the posters may be based on in this context – they demonstrate plausibly that by opting for "black and white" as a system, design can win back its power, and colour its urgency.

Felix Studinka

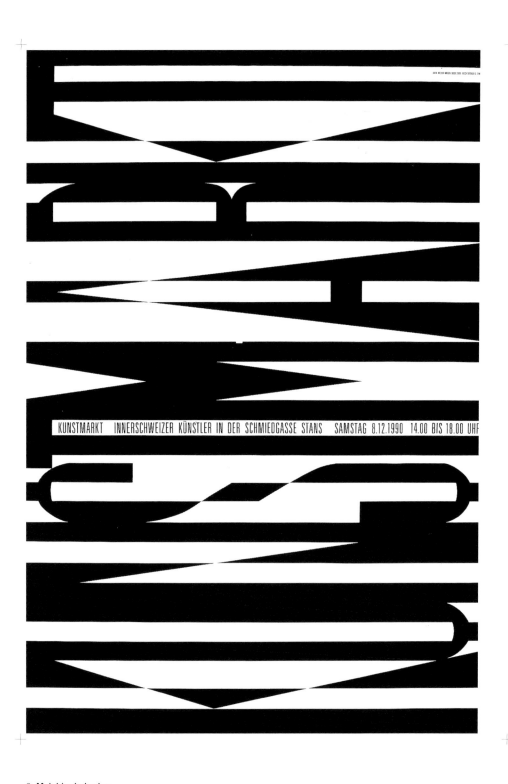

Inside the poster image:
KUNSTMARKT INNERSCHWEIZER KÜNSTLER IN DER SCHMIEDGASSE STANS SAMSTAG 8.12.1990 14.00 BIS 18.00 UHR

2 **Melchior Imboden**
Kunstmarkt – Art market
1991

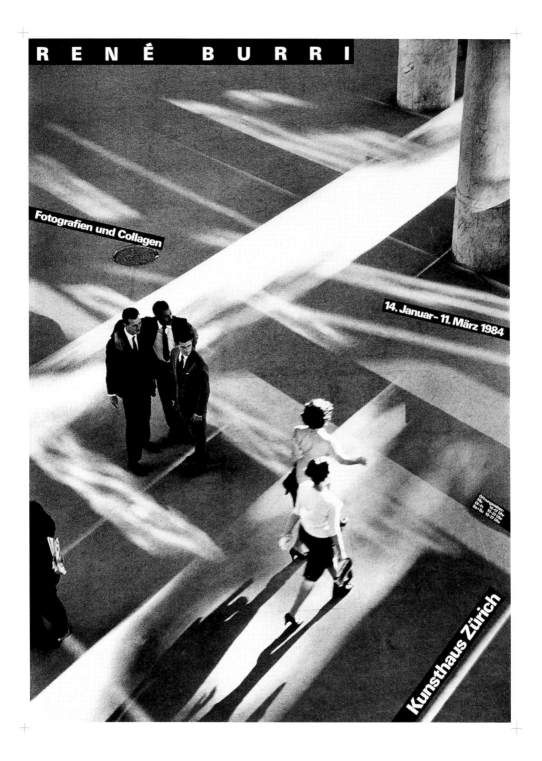

3 **Werner Jeker**
René Burri
1985

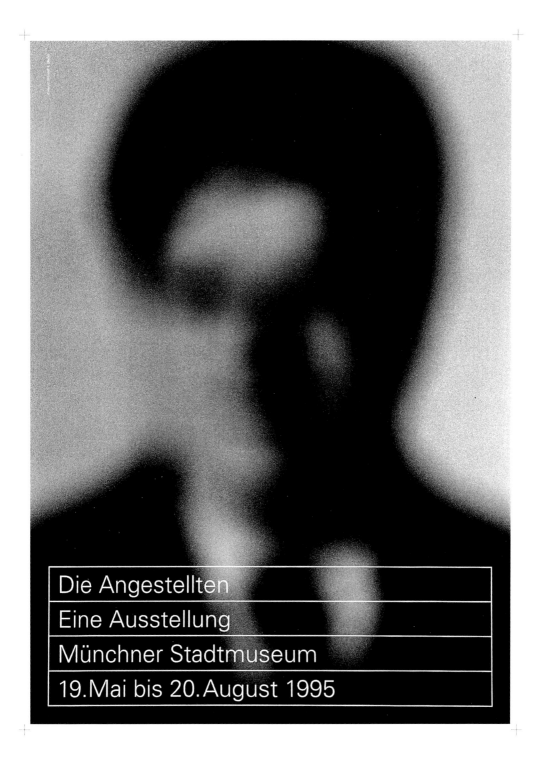

Die Angestellten

Eine Ausstellung

Münchner Stadtmuseum

19.Mai bis 20.August 1995

4 **Pierre Mendell, Markus Frank**
Die Angestellten – The employees
1995

Istituto statale d'arte
Monza
1 via Giovanni Boccaccio

5 **AG Fronzoni**
Istituto statale d'arte
1970

SUDAN

6 **Luba Lukova**
Sudan
1999

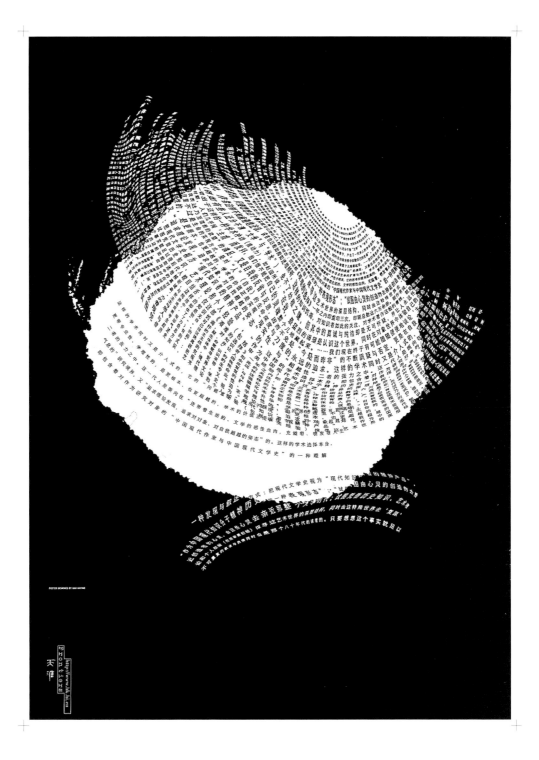

7 **Han Jiaying**
Frontiers
1999

«…Meine Sprache ist schwarzweiss.
Doch das Schwarz-Weiss beraubt uns nicht der Farben –
es markiert die extremen Pole eines Raums,
der sie enthält und in sich birgt.
Nur sind die Farben darin nicht einfach vorhanden.
Es bedarf der Aktivität des Betrachters,
der sich mit dem Raum misst, den Raum durchquert,
damit dieser seine Farbigkeit preisgibt: Der Raum ist grossmütig.
Aber die Farbe will erobert werden. Denn sie ist nichts,
was uns äußerlich wäre:
Die Farbe ist in uns; die Farbe sind wir selbst.»[1]

AG Fronzoni

[1] aus: AG Fronzoni, Sie dachten ich sei verrückt, aber sie liessen mich gewähren.
Lars Müller Publishers, Baden 1998

AUF FARBE VERZICHTEN

Lars Müller

Visuelle Medien durchliefen in ihrer Entwicklung eine prototypische Phase der schwarz-weissen Beschränkung. Fotografie, Film, Television und Drucktechniken sind diesem «Evolutionsgesetz» gefolgt. Wachsende Datenmengen haben sich in Bildschärfe und Farbigkeit niedergeschlagen und das Abbild der Wirklichkeit um das entscheidende Stück näher gebracht. Die Wirklichkeit ist farbig und es erstaunt weiter nicht, dass ihre mediale Wiedergabe dieser Tatsache nacheifert.

Zu beeindrucken vermag uns hingegen die schwarz-weisse Gegenwelt. Der Vorsatz der Nicht-Verwendung von Farbe bei offensichtlicher Verfügbarkeit fordert den Betrachter heraus, denn der Farbverzicht deutet auf eine höhere Absicht hin.

Aus der Wohlstandsoptik wird hinter jedem Verzicht ein bedauerlicher Mangel vermutet oder aber Askese. Letzteres beunruhigt, weil sich dahinter wiederum eine Einsicht zu verbergen scheint. Ihr auf die Spur zu kommen, ist das Ziel dieser Auseinandersetzung. Im Fokus der Betrachtung steht das Plakat. Im günstigen Fall verweist die Erkenntnis auf andere, vielleicht auf alle Gestaltungsgebiete.

Eine Kultur des Verzichts ist in allen Zivilisationen dieser Welt zu verzeichnen. Meistens steht sie als Privileg den geistigen und theologischen Eliten zu. Materieller Verzicht, so die These, bringt einen der Wahrheit näher. Er läutert und lässt das Wesentliche erkennen. Im profanen Alltag ist der Verzicht ein Mittel zur Korrektur. Er bringt das Budget ins Lot und ebenso das Körpergewicht. Er fällt schwer, weil die Umstände des Verzichtens als Verlust und Einschränkung wahrgenommen werden und die Sehnsucht nach uneingeschränkten Mitteln und Möglichkeiten erhalten bleibt. Von einem Gewinn aus Verzicht hören wir gegebenenfalls von Nichtrauchern, Fussgängern und Vegetariern.

Legen wir also diese Alltagserfahrungen unserer auf Schwarzweiss ausgerichteten Betrachtung der Plakatgestaltung zugrunde. Hier, wie im Leben, ist Verzicht häufiger eine auferlegte Bürde als die Folge von Erkenntnis. Beschränkte Mittel und Möglichkeiten beeinflussen die Gestaltung und müssen als Erklärung für schlechtes Gelingen herhalten. Tatsächlich ist die Qualität von Papier, Reproduktion und Druck gerade beim Plakat von entscheidender Bedeutung und steht in einem direkten Zusammenhang mit Kosten und Erschwinglichkeit. Für die Qualität der Gestaltung sind diese Faktoren nicht massgebend.

Gehen wir davon aus, dass die Vermittlung eines bestimmten und vorgegebenen Inhalts der Zweck einer entwerferischen Handlung ist und einzig das gewählte Medium, sagen wir das Plakat, diesen Prozess konditioniert, so rücken alle

anzunehmenden Einschränkungen der Produktionsmittel in den Hintergrund. Die Idee wird sich die Mittel zu ihrer wirkungsvollen Umsetzung im Rahmen der verfügbaren Ressourcen suchen.

Die Zeit ist ein wesentlicher Faktor dieser Ökonomie. Wieder nützt es nichts, Zeitnot als Ursache des Scheiterns anzuführen. Es grenzt an Dilettantismus, wenn in guter Absicht ein Entwurf an der Fehleinschätzung der zeitlichen und materiellen Kapazitäten scheitert. Verzicht kann der vorsätzliche Teil einer Strategie sein, um mit beschränkten Mitteln – Zeit wie Geld – zu einem guten Resultat zu gelangen. Als Beispiel mögen die Plakate des Pariser «Mai 68» dienen, wo die Dringlichkeit der Kommunikation dem vergessen geglaubten Linolschnitt zu neuer Blüte verhalf. Die Einfarbigkeit als Folge der ökonomischen Einschränkung macht sich in diesen Plakaten nicht als Verlust bemerkbar. Ihre Stärken sind der expressive Ausdruck, die Komposition und der Bildwitz.

Der Farbverzicht war in der Plakatgestaltung immer auch ein Mittel zur Abgrenzung. Die bunte Farbigkeit der kommerziellen Werbung dominierte zu allen Zeiten die Präsenz des Plakates im öffentlichen Raum. Der Verzicht auf Farbe ist die absichtsvolle Verweigerung, im Wissen, dass die Abwesenheit im Auge des Betrachters eine «Fehlermeldung» bewirkt und die Wahrnehmung auf Form und Komposition, auf die grafische Qualität und auf die Botschaft lenken wird.

Tatsächlich sind die Wirkungszusammenhänge von verblüffender Einfachheit. Das Primat der Form, ob konstruktiv, expressiv, abstrakt, pathetisch, poetisch, appellierend oder sachlich nüchtern, wird mit der Abwesenheit von Farbe offensichtlich und unausweichlich. Schwarz auf Weiss werden Buchstaben zu autonomen Bildelementen, Fotografien zu Sinnbildern, Konstruktionen zu Mustern. Und der Betrachter entdeckt seine Begabung, in der binären Struktur zwei Bilder zu lesen: das Schwarze und das Weisse.

Ein schwarz-weiss geschultes Gestalterauge weiss diese Möglichkeiten zu nutzen. Wie in Fotografie und Film stellt der Verzicht auf Farbe in der Plakatgestaltung das Ausserordentliche dar. Auf diesen Effekt zu vertrauen ist keine Frage der Tugend, sondern der Fachkunde. In diesen Disziplinen haben sich traditionelle Prinzipien erhalten und kontinuierlich weiter entwickelt. Sie sind erlernbar geblieben. Die aktuellen Plakate in dieser Sammlung stimmen in den Voraussetzungen ihrer visuellen Wirkung denn auch mit den Beispielen aus den sechziger und siebziger Jahren überein. Damals war mit dem Verzichtsentscheid allerdings eine Haltungsfrage verbunden. Vielen Plakaten aus jener Zeit haftet etwas Bekenntnishaftes an. Manche Gestalter haben aber im Geist der Moderne in der Reduktion und Vereinfachung ihrer Gestaltung eine grosse Meisterschaft erlangt.

Ein Meister dieser Gattung war AG Fronzoni (1923–2002), der sich in seltener Ausschliesslichkeit dem schwarz-weissen Plakat verschrieben hat. Geradezu programmatisch wirkt deshalb sein farbiger Entwurf für eine Mailänder Druckerei, *Team Colore* (1973), der dieser Publikation als Umschlag dient. Er vermittelt, ja feiert die Farbe ansich und lässt sie zum unangefochtenen Inhalt des Plakates werden. Selbst in dieser minimalistischen Konzeption ist Spielraum für die Gestaltung: Durch die Gewichtung und das komplementäre Zusammenspiel erlangt das Plakat seine Unverwechselbarkeit. So verfährt Fronzoni auch bei seinen schwarz-weissen Entwürfen. Die Idee ist das formale Skelett, welches die Gestalt des Plakates aus Typografie oder konstruktiven Elementen trägt. Sind die grafischen Mittel bestimmt, wird die Figur modelliert, bis sie als Form in der Fläche ein perfektes Equilibrium bildet.

Fronzonis Tugend ist nicht der Verzicht, sondern die Konzentration. «Schwarz und Weiss als Haltung der Reduktion, die bis zur Auslöschung getrieben wird: das Weniger und das Mehr. Was zählt, ist häufig nicht die Fülle, sondern die Leere und die Abwesenheit, Beiträge zur Dekonstruktion und Konstruktion eines totalen, im wesentlichen geistigen Raums, einer inneren Ordnung.»

Diese Radikalität wohnt, zumindest potenziell, jeder Gestaltung mit Schwarz und Weiss inne. Reduktion ist dabei eine der möglichen Entwurfsstrategien. Überlagerung und Verdichtung sind andere, der heutigen Ästhetik und Arbeitsweise näherliegende Methoden. Am deutlichsten manifestieren sich diese unterschiedlichen Wege zum gemeinsamen Ziel in den zeitgenössischen Arbeiten japanischer Gestalter, die minimalistisch kompakt bis sphärisch leicht ihr traditionelles Urvertrauen in die Kraft der schwarzen Farbe auf weissem Grund zum Ausdruck bringen (s. S. 44ff).

Ob in der Tradition fernöstlicher Kunst, in der Haltung der europäischen Moderne oder vorbildlos aus eigener Erfahrung: Schwarz-Weiss ergibt sich nicht, sondern gründet immer auf der Entscheidung des Gestalters. Dem Betrachter mutet er zu, was er von sich selber erwartet – die Komplexität, Fülle und Poesie des Einfachen zu erkennen, denn «die Farbe ist in uns, die Farbe sind wir selbst».

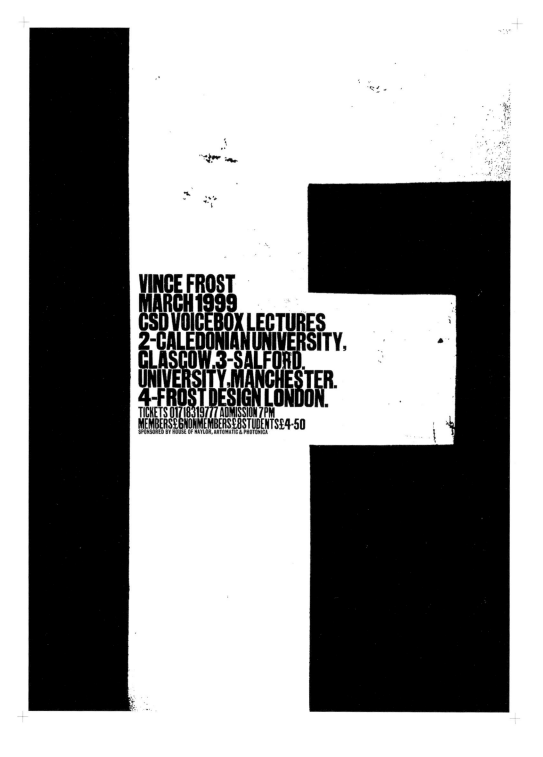

VINCE FROST
MARCH 1999
CSD VOICEBOX LECTURES
2-CALEDONIAN UNIVERSITY,
GLASGOW.3-SALFORD.
UNIVERSITY.MANCHESTER.
4-FROST DESIGN LONDON.
TICKETS 01718319777 ADMISSION 7PM
MEMBERS£6NONMEMBERS£8STUDENTS£4-50
SPONSORED BY HOUSE OF NAYLOR, ARTOMATIC & PHOTONICA

8 **Vince Frost**
Vince Frost / CSD Voicebox lectures
1999

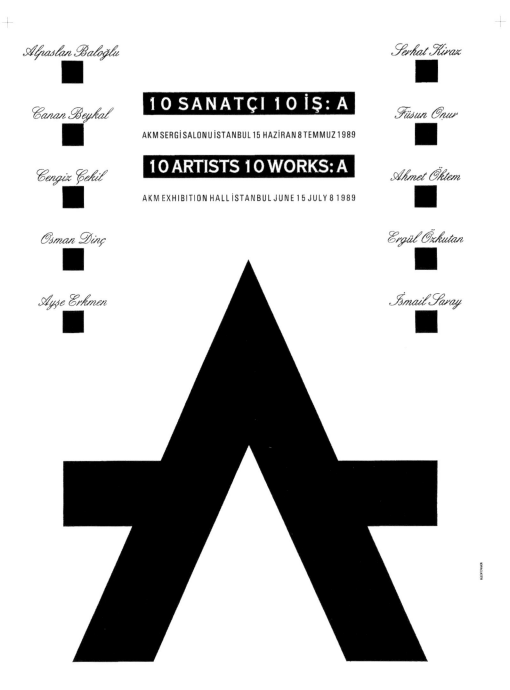

Alpaslan Baloğlu

Canan Beykal

Cengiz Çekil

Osman Dinç

Ayşe Erkmen

Serhat Kiraz

Füsun Onur

Ahmet Öktem

Ergül Özkutan

İsmail Saray

10 SANATÇI 10 İŞ: A

AKM SERGİ SALONU İSTANBUL 15 HAZİRAN 8 TEMMUZ 1989

10 ARTISTS 10 WORKS: A

AKM EXHIBITION HALL İSTANBUL JUNE 15 JULY 8 1989

KOLEKSİYON KURULUŞLARININ KATKILARIYLA GERÇEKLEŞMİŞTİR **KOLEKSİYON** THANKS TO THE CONTRIBUTIONS OF KOLEKSİYON CORPORATION

9 **Bülent Erkmen**
10 artists 10 works: A
1988

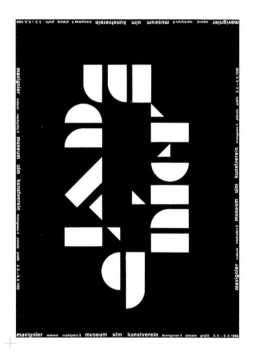

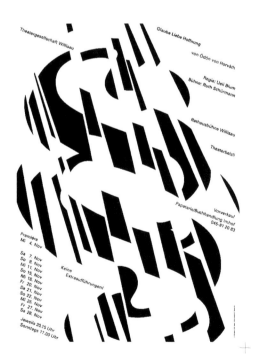

10 **AG Fronzoni**
Sonia Delaunay
1968

11 **Almir Mavignier**
Mavignier
1986

12 **Ralph Schraivogel**
B-4 / Serigraphie Uldri
1992

13 **Niklaus Troxler**
Gaube Liebe Hoffnung von Ödön von Horvath
Faith Love Hope by Ödön von Horvath
1992

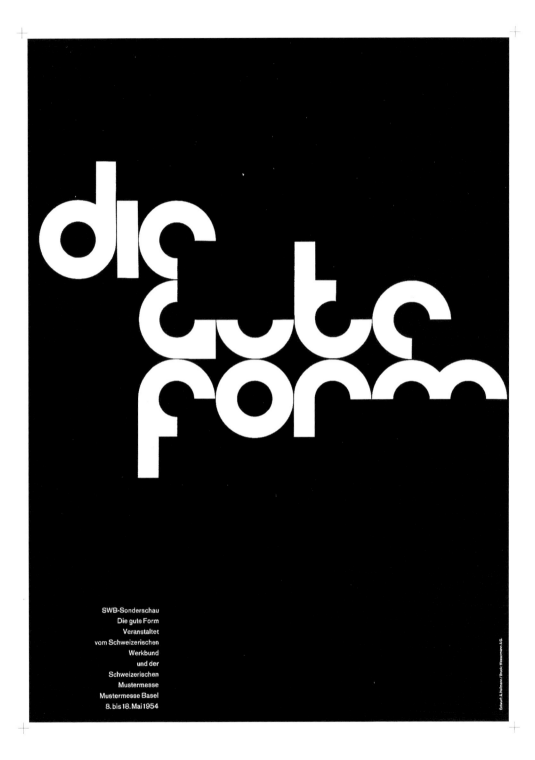

14 **Armin Hofmann**
Die gute Form – Good Design
1954

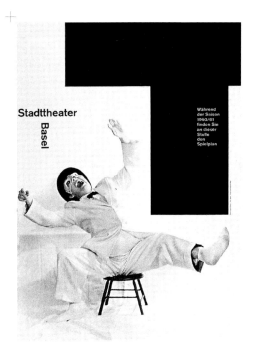

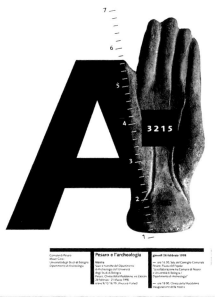

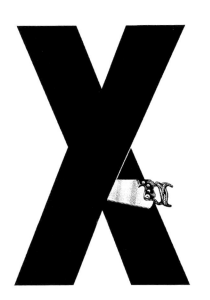

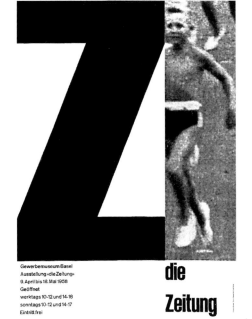

15 **Armin Hofmann**
Stadttheater Basel
1960

16 **Woody Pirtle**
The letter «Y» designed by Woody Pirtle
1994

17 **Leonardo Sonnoli**
A / Pesaro e l'archeologia
1998

18 **Emil Ruder**
Z / Die Zeitung – The newspaper
1958

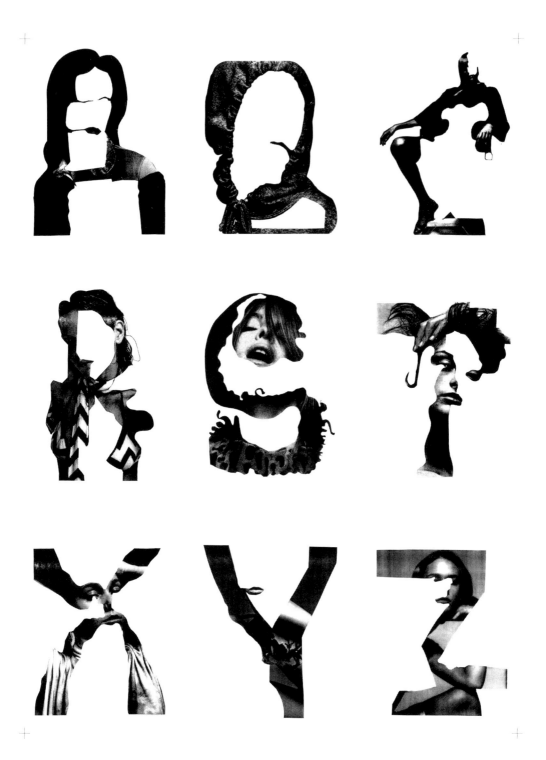

19–27 **M/M (Paris)**
[The Alphabet/Ann-Catherine, Bridget,
Carmen Maria, Frankie Rayder, Stephanie Seymour,
Trish, Xeyenne, abbeY, Zoe]
2001

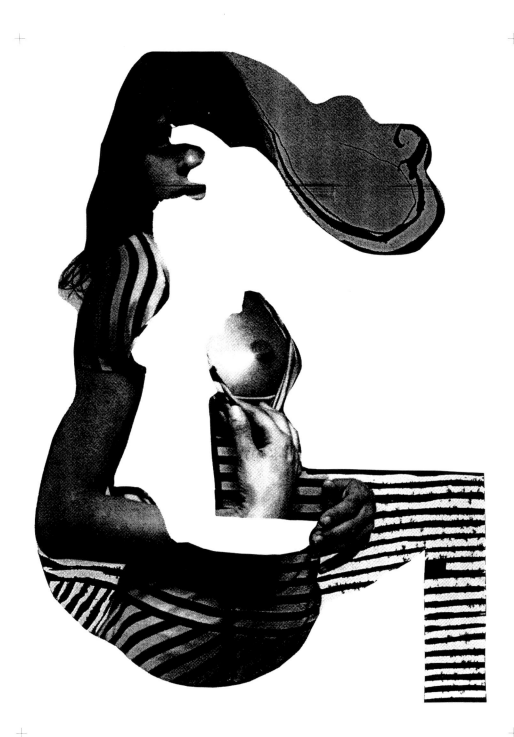

28 **M/M (Paris)**
[The Alphabet / Griet]
2001

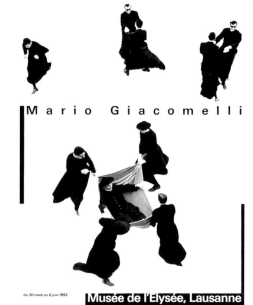

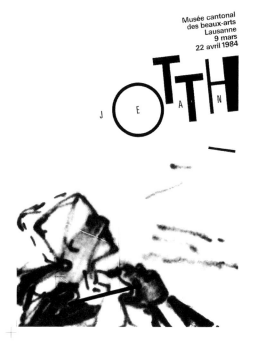

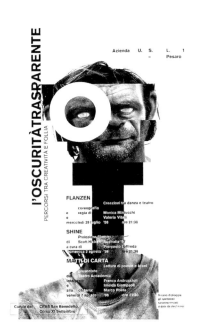

29 **Werner Jeker**
Aaron Siskind
1994

30 **Werner Jeker**
Jean Otth
1984

31 **Werner Jeker**
Mario Giacometti
1993

32 **Leonardo Sonnoli**
L'Oscurità trasparente / Percorsi tra creatività e follia
1998

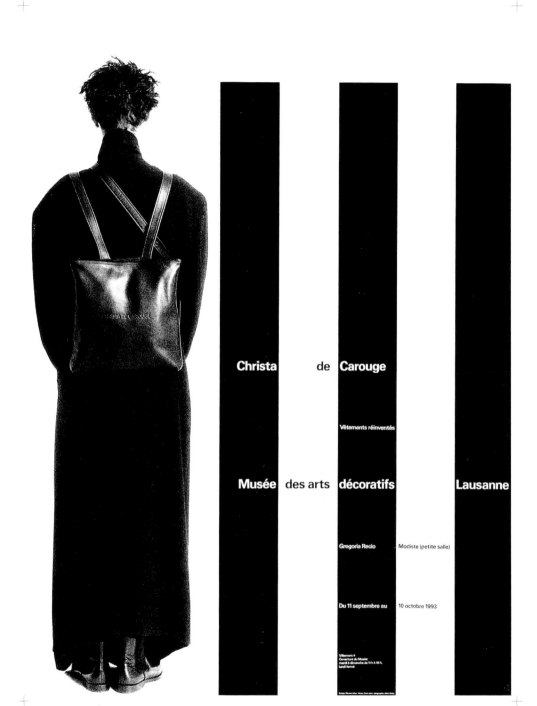

Christa de **Carouge**

Vêtements réinventés

Musée des arts **décoratifs** **Lausanne**

Gregoria Recio Modiste (petite salle)

Du 11 septembre au 10 octobre 1993

Villamont 4
Ouverture du Musée:
mardi à dimanche de 11 h à 18 h,
lundi fermé

33 **Werner Jeker**
Christa de Carouge
1993

"…my language is black-and-white.
Far from depriving us of colour –
the black and the white demarcate the extreme poles in a space,
where it is held and sheltered.
And yet, the colours aren't simply there.
Only as we engage the space and become active
do we uncover the colour in it: the space is generous.
But the colour begs to be conquered.
Colour isn't outside of us: it is intrinsic.
Colour – that is us."[1]

AG Fronzoni

[1] from: AG Fronzoni, They thought I was crazy, but they went along with it.
Lars Müller Publishers, Baden 1998

DOING WITHOUT COLOUR

The visual media went through a prototypical development phase when they were limited to black and white. Photography, film and printing techniques followed this "law of evolution". Growing data quantities have been reflected in sharper images and colour quality, and have brought representations a crucial step nearer to reality. Reality is in colour, and so it is not at all surprising that media reproduction of that reality tries to emulate this fact.

But the counter-world of black-and-white can also impress. Deciding not to use colour when it is obviously available presents a challenge to the viewer: doing without colour suggests a higher purpose.

The perspective of affluence leads people to assume some unenviable deficiency on every occasion when colour is not used, or indeed an ascetic aspect. The latter is disturbing because it seems to rest on a certain insight. The present study aims to track this down. The poster is at the centre of the investigation. But in appropriate cases the insights can extend to other, and perhaps to all, areas of design.

Cultures of denial can be identified in all this world's civilizations. Usually it is seen as the privilege of a spiritual and theological élite. Material denial, so the theory runs, brings people closer to the truth. It purifies and makes it possible to discern essentials. In everyday life, denial is a means of correction. It can balance the budget, and our body weight as well. It does not come easily to us because the circumstances of denial are perceived as loss and limitation, and a desire for unlimited resources and possibilities persists. We may well hear non-smokers, pedestrians and vegetarians talking of how they have benefited from denial.

So let us base our consideration of the black-and-white poster design perspective on these everyday experiences. Here, as in life, denial tends to be an imposed burden rather than the result of an insight. Limited resources and possibilities influence design and have to serve as explanations of failure. And in fact the quality of paper, reproduction and printing are crucially important for posters in particular, and directly connected with cost and affordability. These latter factors are not decisive for the quality of design.

Let us assume that the purpose of an act of design is to convey a certain prescribed content and that only the medium chosen, let us say the poster, determines this process; thus all the limitations relating to production devices that have to be accepted shift into the background. The idea will identify means of effective implementation within the context of the available resources.

Time is a crucial factor in this economic system. Again it is no use trying to blame failure on lack of time. It is verging on dilettantism if, despite the best intentions, a design founders because the time and materials available have been wrongly assessed. Denial can be deliberately built into a strategy for achieving a good result with restricted means – in terms of time and money. The posters for "May 68" in Paris are a good example here. The urgent need to communicate brought the lino-cut, which everyone thought had been forgotten, back to centre stage. Monochrome design as a result of economic constraints is not a negative quality in these posters. Their strengths are expressiveness, composition and pictorial wit.

Foregoing colour in poster design was always a means of differentiation. Commercial advertising's bright colours always dominated posters in public places. Abandoning colour is a deliberate refusal, in full knowledge that this absence will trigger an "error message" in the viewers' eyes, directing their attention to form and composition, to graphic quality and the message conveyed.

In fact the means available for creating effects are astonishingly simple. The primacy of form, whether it is constructive, expressive, abstract, emotional, appealing or functionally neutral will become obvious and inevitable when colour is absent. When they are black on white, letters become autonomous pictorial elements, photographs become symbols, constructions become patterns. And viewers discover their talent for reading two images in the binary structure: the black one and the white one.

A designer's eye trained in black and white knows how to exploit these possibilities. As in photography and film, not using colour in poster design is seen as extraordinary. Trusting in the effect it will produce is not about virtue, it is about expert knowledge. Traditional principles have survived in these disciplines and have continuously developed further. It is still possible to learn them. The contemporary posters in this collection fit in with the examples from the sixties and seventies in the requirements behind their visual effects, though at that time the decision not to use colour was linked with a question of attitude. There is something of a declaration of faith in many posters from this period. But many designers achieved great mastery in reducing and simplifying their designs in the spirit of Modernism.

One master of this genre was AG Fronzoni (1923–2002), who devoted himself to the black-and-white poster with rare exclusivity. And so his coloured design for a Milan printing firm, *Team Colore* (1973), which is used as the cover of this book, gives the impression of being a programme in its own right. He conveys, indeed celebrates, colour as such: it is indisputably what the poster is about. There is room for creative design even within this minimalist concept: the poster acquires

its unmistakable quality from weighting and from the interplay that complements this. Fronzoni approached his black-and-white designs like this as well. The idea is the formal skeleton that supports the form of the poster, which consists of typography or constructive elements. Once the graphic resources are determined, the figure is modelled until it provides perfect balance as surface form.

Fronzoni's virtue is not denial, but concentration. "Black and white as a reductive approach that is taken to the point of extinction: less and more. What counts is frequently not abundance but emptiness and absence. Contributions to the deconstruction and construction of a total space, essentially a spiritual one, an inner order."

This radical quality is inherent in every design in black and white, at least inherently. Here reduction is one of the possible design strategies. Superimposition and condensation are other methods, closer to current aesthetics and working methods. These different paths to a common goal can be seen most clearly in the contemporary work of Japanese designers, who effortlessly express their traditional, primeval faith in the power of black colour on a white, ground, minimalist and compact, or spherical. (see pp. 44 ff.)

Whether it follows the tradition of Far Eastern art, adopts the approach of European Modernism or has no model other than the designer's own experience: black and white does not just happen, it is always based on the designer's decision. The viewer expects of it what it expects of itself – recognizing the complexity, abundance and poetry of the simple, for "colour is in us, we are colour ourselves."

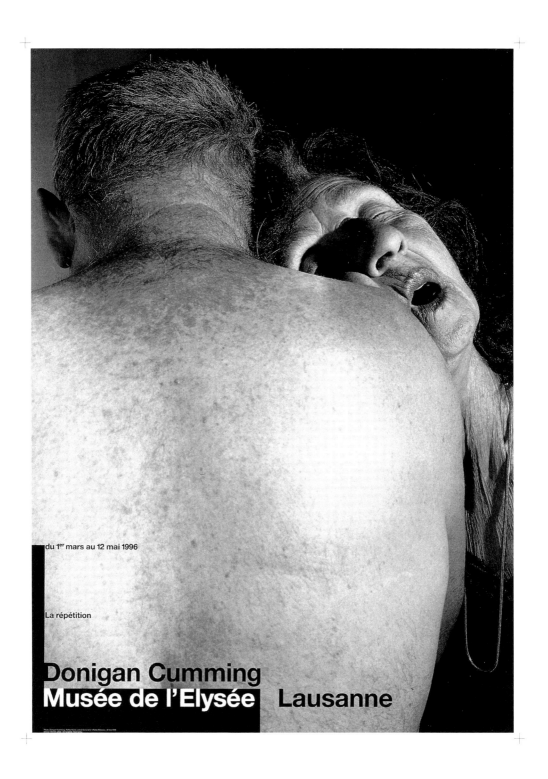

du 1er mars au 12 mai 1996

La répétition

Donigan Cumming
Musée de l'Elysée Lausanne

34 **Werner Jeker**
Donigan Cumming
1996

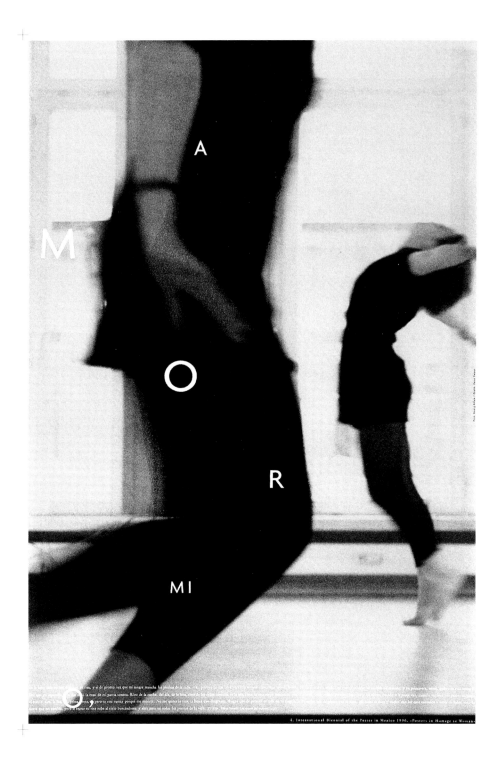

35 **Peter Felder**
Amor mio
1997

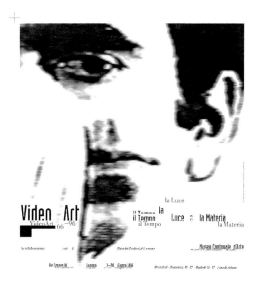

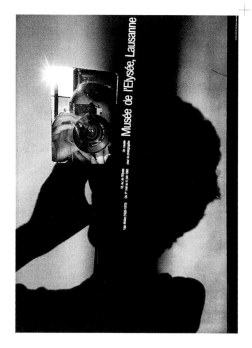

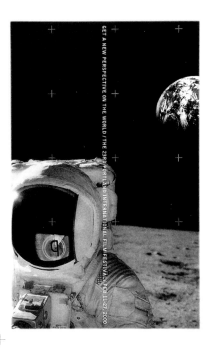

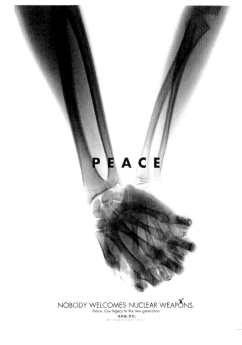

36 **Bruno Monguzzi**
Video Art / Il tempo / La luce / La Materia
1996

37 **Steve Sandstrom**
Get a new perspective on the world
2000

38 **Werner Jeker**
Ugo Mulas
1986

39 **Naoki Hirai**
Peace
2000

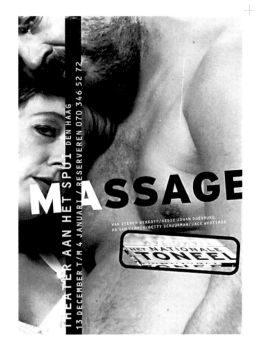

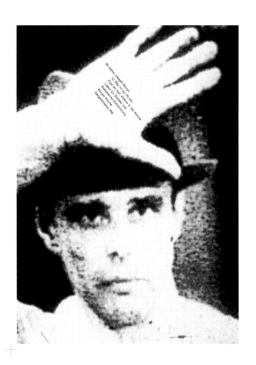

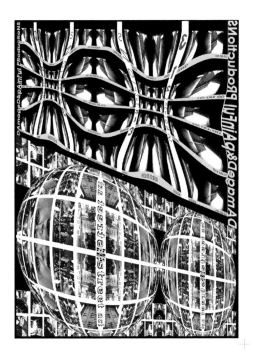

40 **Ralph Schraivogel**
Gross und Klein – Large and small
1997

41 **Fons Matthias Hickmann**
80 Jahre Joseph Beuys – 80 years of Joseph Beuys
2001

42 **Studio Dumbar / Catherine van der Eerden**
Massage
1996

43 **Bob Vinteller**
Her street Act / 312 Sections
2001

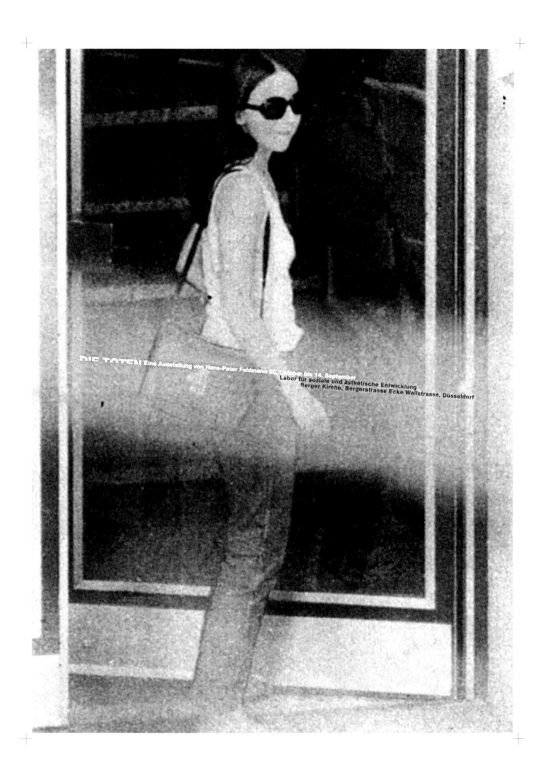

44 **Fons Matthias Hickmann**
Die Toten – The dead
2001

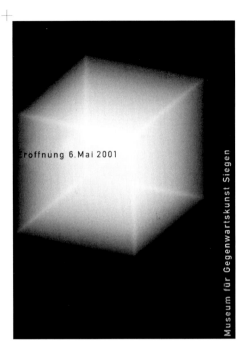

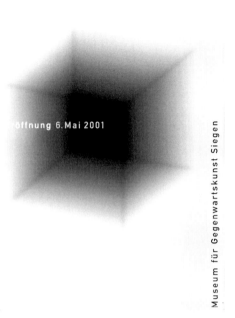

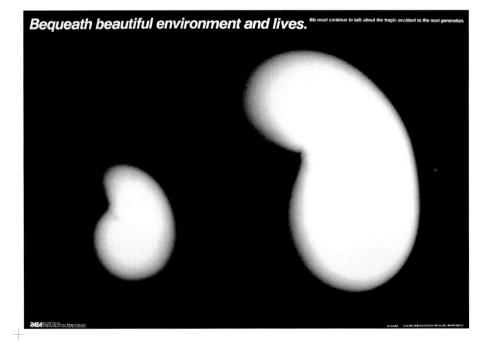

45/46 **Uwe Loesch, Gunnar Fiel**
Museum für Gegenwartskunst Siegen
2001

47 **Yoshiteru Asai**
Bequeath beautiful environment and lives.
1987

48 **Jurij Surkov**
Idea
2000

49 **Alejandro Magallanes**
Proyecto Goya Posada
2002

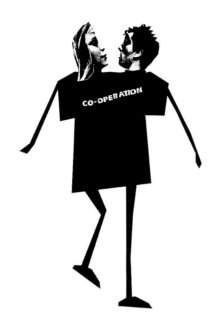

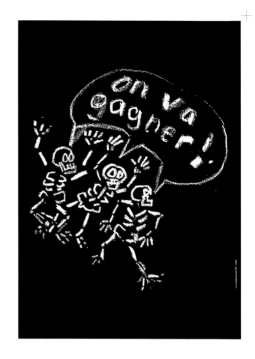

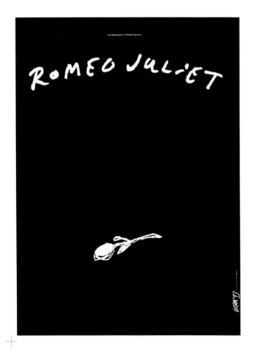

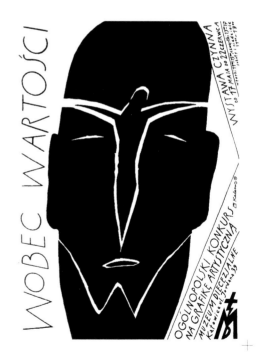

50 **Xiaoming Zhang**
Co-operation
2001

51 **James Victore**
Romeo Juliet
1993

52 **Nous travaillons ensemble / Grapus**
On va gagner!
1991

53 **Roman Kalarus**
Wobec Wartosci
1986

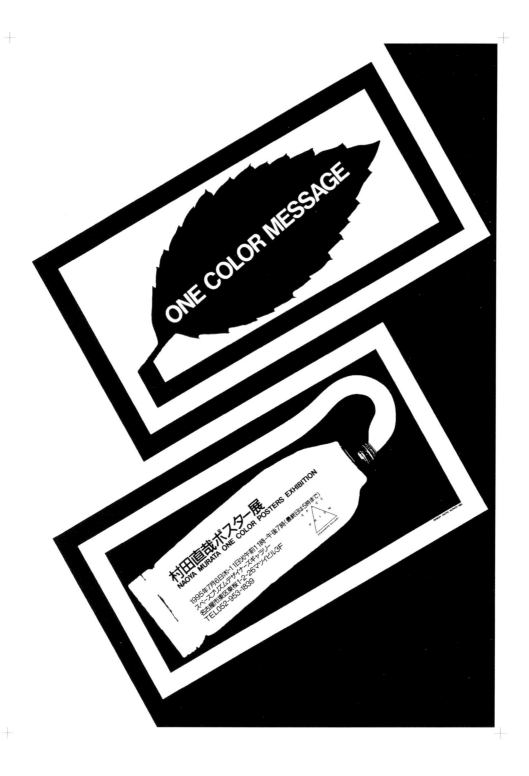

54 **Naoya Murata**
One color message
1995

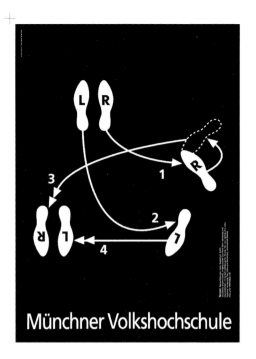

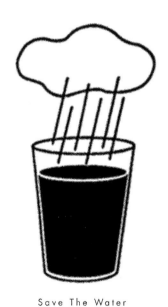

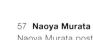

Save The Water

55 **Pierre Mendell, Heinz Hiltbrunner**
Münchner Volkshochschule
2001

56 **Naoki Hirai**
Save the water
2002

57 **Naoya Murata**
Naoya Murata posters exhibition «one color message».
1995

58 **Gunter Rambow**
Linie 1
1998

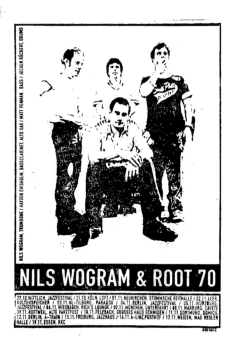

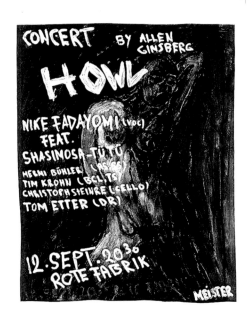

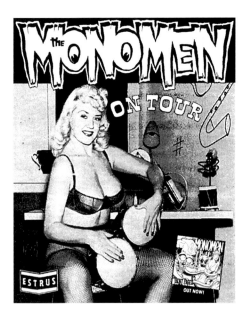

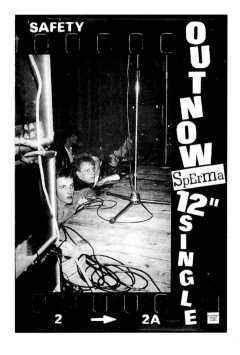

59 **Rio Grafik**
Nils Wogram & Root 70
2000

60 **Art Chantry**
The Monomen on tour
1993

61 **Meister**
Howl / Concert by Allen Ginsberg
ca. 1979

62 **anonym**
Sperma
1979

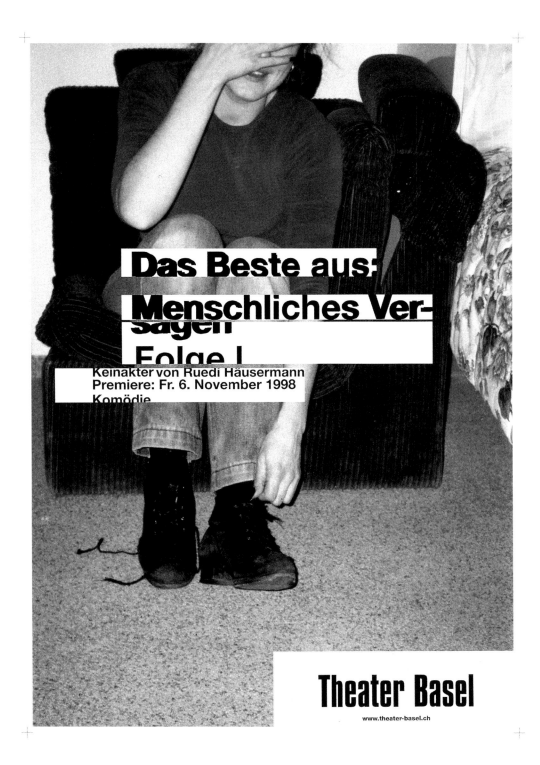

Das Beste aus:

Menschliches Ver-
~~sagen~~

~~Folge I~~
Einakter von Ruedi Häusermann
Premiere: Fr. 6. November 1998
Komödie

Theater Basel

www.theater-basel.ch

63 **Tschumi, Küng**
Das Beste aus: Menschliches Versagen
The best of: Human error
1998

64 **Ryuichi Yamashiro**
Hayashi/Mori
1955

DIE SCHÖNHEIT VON WEISSEM REIS IN SCHWARZEM GEFÄSS – SCHWARZ UND WEISS IM OSTASIATISCHEN PLAKAT
Bettina Richter

«Und dann vor allem der Reis: Gibt man ihn in einen glänzenden, schwarzlackierten Reisbehälter und stellt man ihn an einem dunklen Ort auf, dann ist er nicht nur schön zum Anschauen, sondern regt auch den Appetit an.»[1]

«Wenn eine junge Frau im schwankenden Laternenschatten von Zeit zu Zeit lächelt und zwischen irrlichternden, bläulichen Lippen lackschwarze Zähne aufblitzen lässt, dann kann ich mir kein weisseres Gesicht als dieses vorstellen. (…) Mag sein, dass ein solches Weiss in Wirklichkeit gar nicht existiert. Mag sein, dass es nur ein augenblickliches, aus Licht und Dunkel zusammengebrautes Blendwerk ist. Aber uns genügt es; wir können gar nicht auf mehr hoffen.»[2]

Der Autor dieser Zeilen, Tanizaki Jun'ichiro, preist in seinem 1933 verfassten Essay «Lob des Schattens» das Zusammenspiel von Helligkeit und Dunkelheit, von Licht und Schatten, von Tag und Nacht. Jun'ichiro beschreibt den elementarsten Farbkontrast als ein der japanischen Alltagsästhetik inhärenter Gegensatz: Er wiederholt sich in der Darbietung der Mahlzeiten, im Schönheitsempfinden der Frauen, in der Architektur und Innengestaltung der Wohnungen. Die Symbiose von Leben und Lebensraum, die den japanischen Alltag bestimmt hat und wesentlich im Zen-Buddhismus wurzelt, widerspiegelt sich in diesem farblichen Zweiklang. Auf farbsymbolischer Ebene erfüllt er die Gesamtheit des Daseins durch wechselseitige Ergänzung im Sinne des chinesischen Yin-Yang-Prinzips.

Trotz des Stilpluralismus in den Arbeiten von Grafikdesignern aus Japan und China ist auffallend, dass sich viele Gestalter ganz auf die Wirkung der schwarzen Druckfarbe auf weisser Unterlage verlassen. Der Gestaltung in Schwarz und Weiss gewinnen sowohl Momente kühner Provokation als auch konzentrierter Stille ab, eine raffinierte Balance zwischen hoher Spannung und harmonischer Ausgewogenheit. Auch im Grafikdesign reflektiert sich also ein ästhetisches Bewusstsein, das seine Wurzeln in der mentalitätsgeschichtlich und philosophisch begründeten Präferenz von Schwarz und Weiss besitzt.

Charakteristika, die das ostasiatische Plakatschaffen im allgemeinen kennzeichnen, erfahren in Plakaten, die auf jede Buntfarbe verzichten, noch eine Steigerung. Ihre sinnlich-poetische Suggestionskraft erfüllt sich in einzelnen Werken in minimalistischer Formkompaktheit, geometrischer Abstraktion und einer klaren Konstituierung von Flächen- und Raumbezügen, in anderen Arbeiten gerade in der Transparenz, im Sphärisch-Räumlichen und einer fast mystischen Leichtigkeit.

Die traditionellen ästhetischen Prinzipien *sabi* und *wabi*, die der Grafikdesigner Naoki Hirai als Schönheit der Einfachheit und Schönheit der Ruhe definiert, verdeutlichen eine weitere wichtige Grundlage fernöstlicher Ästhetik, die Alltag und Kunst verbindet. Die hohe Wertschätzung einfacher Alltagsgegenstände, die in streng funktionaler Orientierung in Ostasien über Jahrhunderte dem gleichen Formenkanon folgen, sind Ausdruck einer asketischen Grundhaltung, die in der Konzentration und Beschränkung auf das Wesentliche auch die Kunst dieses Kulturraumes prägen. Nicht von ungefähr wird *kirei* mit *schön, einfach, rein* übersetzt. Und die höchste Form von *kirei*, so Koichi Sato, ist ein weisses Papier.[3] Leerflächen in zweidimensionalen Werken, zumeist Weissflächen, werden gemäss buddhistischer Auffassung nicht eigentlich als Leere, sondern als erfüllter Raum wahrgenommen, als Ausdruck spannungsvoller Gelassenheit und intensivster Konzentration. Die Reduktion der Farbpalette auf Schwarz und Weiss schreibt sich also auch in diesen formalen Kontext ein.

Ein anderer Zugang für die Vorliebe von Schwarz und Weiss im ostasiatischen Grafikdesign eröffnet sich über dessen Rückbezug auf das traditionelle Kulturerbe. Die Kalligrafie gilt bis heute als erste und höchste Kunst Ostasiens, die selbst der Malerei übergeordnet ist und diese durch die Dominanz der Linie wesentlich beeinflusst hat. Die Schriftzeichen geniessen in ihrer ästhetischen Formvollendung fast magische Verehrung und sind für den westlichen Blick auch ohne Wissen um ihre Bedeutung von grosser Faszination. Die chinesische Schrift, aus der die japanische hervorgegangen ist, verfügt mit 50 000 Zeichen über sehr viel mehr bildhafte als phonetische Zeichen. Als eine Ikone japanischer Plakatkunst gilt nicht zufällig Ryuichi Yamashiros Plakat *Baum / Hain / Wald* von 1955, das sich einzig auf die visuellen Qualitäten des Schriftzeichens *ki* verlässt 64. Der piktografische Charakter der chinesischen Schrift geht aus diesem Zeichen mit Bedeutung *Baum* besonders deutlich hervor. Die Kombination zweier Zeichen steht für den *Hain*, drei der Zeichen meint Wald.

In den 80er-Jahren des 20. Jahrhunderts setzte sowohl in Japan als auch in China eine verstärkte Besinnung auf die eigenen Wurzeln ein, was sich in Arbeiten der visuellen Kommunikation vor allem in einer Wiederbelebung typografischer Kompositionen manifestiert, die sich teils des lateinischen Alfabets bedienen, teils die expressive Ausdruckskraft der chinesischen und japanischen Schriftzeichen nutzen.

Der Verzicht auf Farbe ist aber auch in nicht ausschliesslich typografischen Arbeiten als Referenz an die lange Tradition der Kalligrafie und Tuschmalerei zu verstehen. Pinsel, Papier, Tusche und der Reibstein, das waren die «vier Schätze» der chinesischen Literaten. Die weiche, schmiegsame Eigenschaft des Pinsels aus Marder- oder Kaninchenhaar ermöglicht es, dass sich

der Pinselstrich mit einer einzigen Handbewegung von einer gestochen feinen schwarzen Linie flächig verbreitern kann und farblich von tiefstem Schwarz bis zu verschiedenen Graunuancen variiert. Schwarze Tusche, so führt Tai-Keung Kan aus, lässt sich in 5 Abstufungen unterteilen: trocken, tief, dicht, leicht und klar. Das reiche Erbe und die hohe Wertschätzung des Papiers sowie die frühe Erfahrung in Drucktechniken sind ebenfalls wichtige Voraussetzung für ein grafisches Gestalten, das sich ganz auf die Farbe schwarz verlässt und ansonsten auf Papierqualität und hohe technische Präzision vertraut. In seinem Text «Black in the visual arts» rekurriert auch Paul Rand immer wieder auf die ostasiatischen Künste und zitiert Henry P. Bowie mit den Worten, dass gemäss japanischer Auffassung Farben die Augen betrügen könnten, schwarz (*sumi*) hingegen nie.[4] Auch Rand betont nochmals die Qualitäten dieses ursprünglichsten Farbkontrastes, die die Japaner und Chinesen am frühesten erkannt haben und die darin liegt, dass sich Schwarz und Weiss gegenseitig ergänzen, in der Wirkung steigern, leuchtender und farbiger erscheinen. Und gerade in diesem kontrastreichen Zusammenspiel sieht auch er das ganze Leben eingeschlossen.

Vielleicht kann Tai-Keung Kans schwarz-weisse Hommage an Paul Rand, die die typografische Komposition von Rands Dada-Plakat von 1955 aufnimmt, in doppeltem Sinne als Würdigung an Rand gelesen werden 70. Es ist einerseits Ehrung des Schaffens des amerikanischen Grafikdesigners, aber auch Anerkennung von Rands Auseinandersetzung mit den Farben Schwarz und Weiss und seiner Wertschätzung japanischer Ästhetik in diesem Kontext. Nicht zufällig beziehen sich sehr viele zeitgenössische westliche Gestalter, die sich in ihren Arbeiten mit den Möglichkeiten schwarzweisser Gestaltung beschäftigen, immer wieder auf die ostasiatische Kunst. Stellvertretend zitiert Peter Felder: «Zum Thema schwarz/weiss fällt mir ein Text ein von Vilim Vasata, der mich seit Jahren begleitet: 'Die Chinesen haben eine Interpretation der Kunst, der ich schon seit langem anhänge. Natürlich stellt sie nicht nur einen Weg dar, sondern drei Wege: Einfachheit, Unmittelbarkeit und Tiefe. Die Einfachheit, das ist die Ausreifung zum Wesentlichen. Die Unmittelbarkeit, das ist die bleibende Lebendigkeit. Und Tiefe, das ist die überdauernde Qualität.'»

[1] Tanizaki Jun'ichiro, Lob des Schattens, Entwurf einer japanischen Ästhetik, Zürich 1987, S. 31.
[2] ebd., S. 59/60.
[3] Koichi Sato, Hinomaru – Der Kreis der Sonne, in: Museum für Gestaltung Zürich (Hrsg.), Kirei – Plakate aus Japan, 1978–1993, Zürich/Schaffhausen 1993, S. 23.
[4] Paul Rand, Black in the visual arts, in: Harvard University (Hrsg.), Graphic Forms, The arts as related to the book, Harvard 1949, S. 39.

THE BEAUTY OF WHITE RICE IN A BLACK VESSEL
BLACK AND WHITE IN EASTERN ASIAN POSTERS
Bettina Richter

"And then above all the rice: if it is put into a gleaming, black-lacquered rice container and set up in a dark place, it is not just beautiful to look at, it stimulates the appetite as well."[1]

"When a young woman smiles from time to time in the swaying shadow of a lantern, letting her lacquer-black teeth glint between flickering bluish lips, I cannot imagine a whiter face than this. It may be that it is just a momentary illusion, distilled from the light and shade. But it is sufficient for us; we cannot hope for more."[2]

The author of these lines, Tanizaki Jun'ichiro, paid tribute to the interplay of brightness and darkness, of light and shade, of day and night in his 1933 essay "In Praise of Shadow". Jun'ichiro identifies this elemental colour contrast as one that is inherent in everyday Japanese aesthetics: it recurs in the presentation of meals, in the way women perceive beauty, in architecture and in interior domestic design. The symbiosis of life and the space in which it is lived, which has determined everyday life in Japan and is essentially rooted in Zen Buddhism, is reflected in this dual colour chord. On the plane of colour symbolism, it fulfils the wholeness of being through mutual complement, in accordance with the Chinese yin-yang principle.

Despite the stylistic pluralism in the work of graphic designers from Japan and China, it is striking that many of them rely completely on the effect of black printer's ink on a white ground. They are able to produce moments of bold provocation and effects of concentrated stillness by designing in black and white, a sophisticated interplay between high tension and harmonious equilibrium. And so graphic design also reflects an aesthetic awareness rooted in a preference for black and white, itself justified in both philosophy and intellectual history.

Characteristics that are typical of Far Eastern poster art in general are even further enhanced in posters that use no colours at all. Their sensual and poetic power emerges in individual works as minimalistic formal compactness, geometrical abstraction and clearly constituted surface and spatial relationships, then in other works in their very transparency, in spherical three-dimensional qualities and in an almost mystical lightness.

The traditional aesthetic principles of sabi and wabi, defined by the graphic designer Naoki Hirai as the beauty of simplicity and the beauty of repose, illustrate another important fundamental of Far Eastern aesthetics linking everyday life and art. The high esteem accorded to simple everyday objects that have followed the same formal canon in Eastern Asia for

decades, with a strong functional orientation, derives from an ascetic basic approach that also shapes the art of this cultural area in its concentration and restriction to essentials. It is no coincidence that *kirei* is translated as *beautiful*, *simple*, *pure*. And according to Koichi Sato, the highest form of *kirei* is a sheet of white paper.[3] In Buddhist eyes, empty spaces in two-dimensional works, usually areas of white, are not actually perceived as empty, but as filled space, as an expression of tension-filled composure and the most intensive concentration. So reducing the colour range to black and white is also part of this formal context.

Another approach to the preference for black and white in Far Eastern graphic design is via the way it relates back to the traditional cultural heritage. Calligraphy is still seen as Eastern Asia's first and highest art, ranked higher even than painting and influencing this crucially through the dominance of the line. The aesthetic perfection of the written characters means that they enjoy almost magical veneration, and they are very fascinating to Western eyes, without any awareness of their meaning. Chinese script, from which Japanese script emerged, has 50,000 characters, many more of which are pictorial than phonetic. It is not surprising that Ryuichi Yamashiro's 1955 poster *Tree/Grove/Wood*, which relies entirely on the visual qualities of the letter ki, has become an icon of Japanese poster art 64. The pictographic character of Chinese script emerges particularly clearly from this character meaning tree. The combination of two characters stands for a grove, and three make a wood. In the 1980s, both Japan and China thought back more strongly to their own roots. This showed particularly in a revival of typographic composition in works of visual communication, partly using the Roman alphabet and partly the expressive power of the written Chinese and Japanese characters.

But working without colour is not to be seen as harking back to the long tradition of calligraphy and ink painting for works that are not exclusively typographical. Paintbrush, paper, Indian ink and ink block were the "four treasures" of the Chinese man of letters. The soft, supple quality of the paintbrush in marten- or rabbit-hair makes it possible for the brushstroke to open up over an area from a neat, fine black line in a single hand movement, and to vary in hue from the deepest black to various shades of grey. Black ink, Tai-Keung-Han explains, can be divided into 5 gradations: dry, deep, dense, light and clear. The rich legacy of paper, the high esteem in which it is held, along with early experience of printing techniques, are other important prerequisites for graphic design that relies completely on the colour black and otherwise on paper quality and a high degree of technical precision. In his essay "Black in the visual arts", Paul Rand constantly returns to Far Eastern art, quoting Henry P. Bowie's statement that according to the Japanese, colours could deceive the eyes, but black *(sumi)* on the other hand never could.[4] Rand also re-emphasizes the qualities of this earliest of all colour contrasts, which the Japanese and Chinese were the first to recognize and that lies in the fact that black and white complement each other, enhance each other's effect and seem more glowing and chromatic. And he too feels that the whole of life is included in this richly contrasting interplay.

Perhaps Tai-Keung Kan's black-and-white homage to Paul Rand, which adopts the typographical composition of Rand's 1955 Dada poster, can be seen as a double acknowledgement of Rand 70. On the one hand it honours the American graphic designer's output, but also recognizes Rand's examination of the colours black and white and his appreciation of Japanese aesthetics in this context. It is no coincidence that very many contemporary Western designers whose work addresses the possibilities of black-and-white design, keep returning to Far Eastern art. Peter Felder adduces a representative quotation: "On the subject of black and white, I am reminded of an essay by Vilim Vasata that has been with me for some years: 'The Chinese interpret art in a way that I have subscribed to for some time. Of course it does not offer just one path, but three: simplicity, directness and depth. Simplicity, that is maturing towards the essential. Directness, that is lasting vigour. And depth, that is enduring quality.'"

[1] Tanizaki Jun'ichiro, Lob des Schattens, Entwurf einer japanischen Ästhetik, Zurich 1987, p. 31.
[2] ibid., pp. 59/60.
[3] Koichi Sato, Hinomaru – Der Kreis der Sonne, in: Museum für Gestaltung Zürich (publ.), Kirei – Plakate aus Japan, 1978–1993, Zurich/Schaffhausen 1993, p. 23.
[4] Paul Rand, Black in the visual arts, in: Harvard University (publ.), Graphic Forms, The arts as related to the book, Harvard 1949, p. 39.

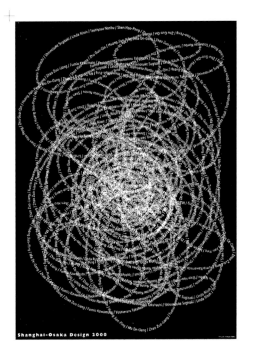

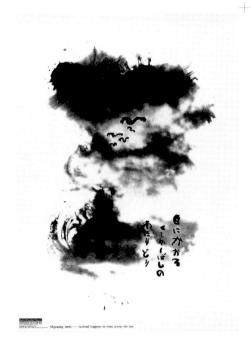

65 **Toshiyasu Nanbu**
Shanghai-Osaka Design 2000
2000

66 **Taku Satoh**
Rebuild/Taku Satoh Design Office Inc.
1992

67 **Yoshiteru Asai**
Migrating Birds...A cloud happens to move
across the sun
1994

68 **Han Jiaying**
Frontiers
2001

PEOPLE

PEOPLE

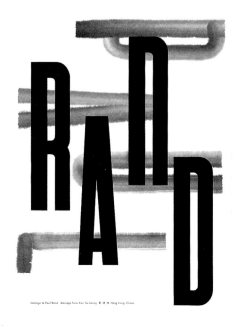

Homage to Paul Rand Message from Kan Tai-keung 靳埭强 Hong Kong, China

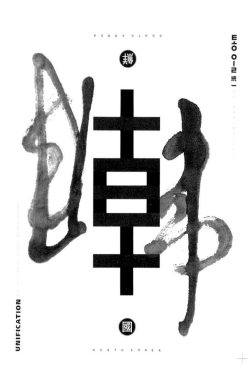

69 **Siu Hong Freeman Lau**
People
2000

70 **Tai-Keung Kan**
Paul Rand
1997

71 **Siu Hong Freeman Lau**
People
2000

72 **Tai-Keung Kan**
Unification / North Korea / South Korea
1997

Designed by Kan Tai-keung 靳埭強設計

73 **Tai-Keung Kan**
Celebrating the New Born of the Museum of Design
1999

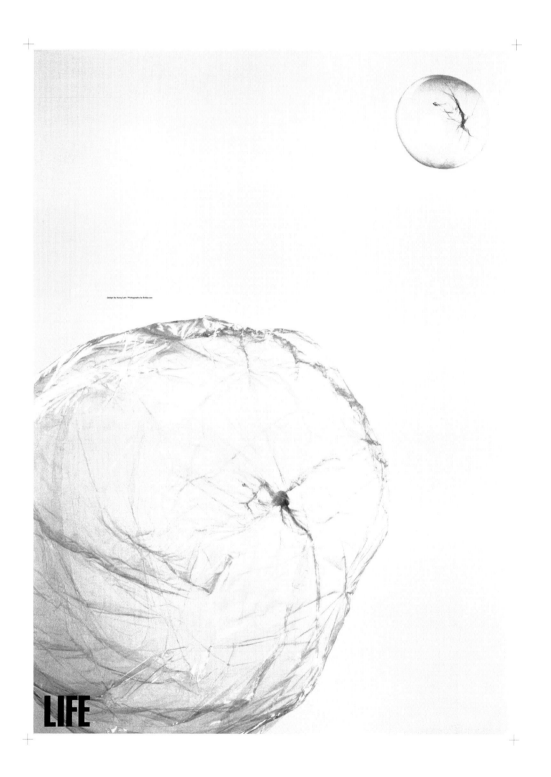

LIFE

74 **Hung Lam**
Life
2001

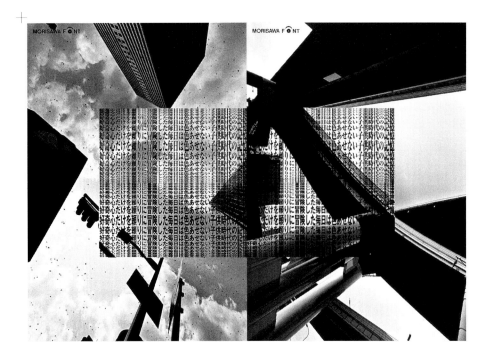

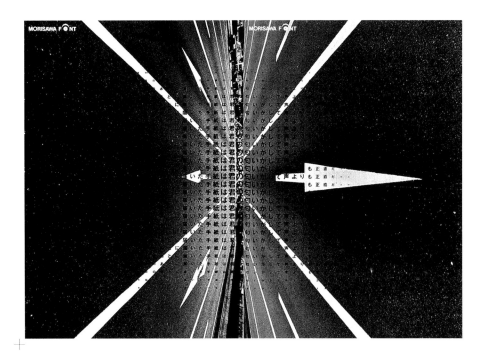

75/76 **Shinnoske Sugisaki**
Morisawa Font
1997

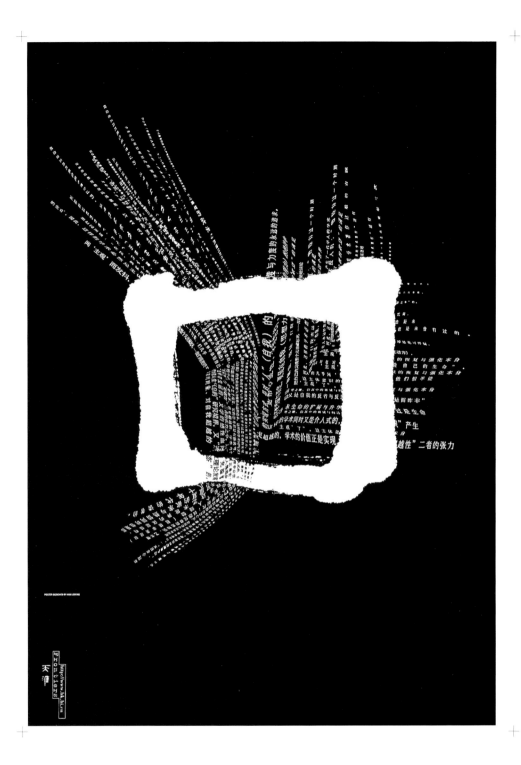

77 **Han Jiaying**
Frontiers
1999

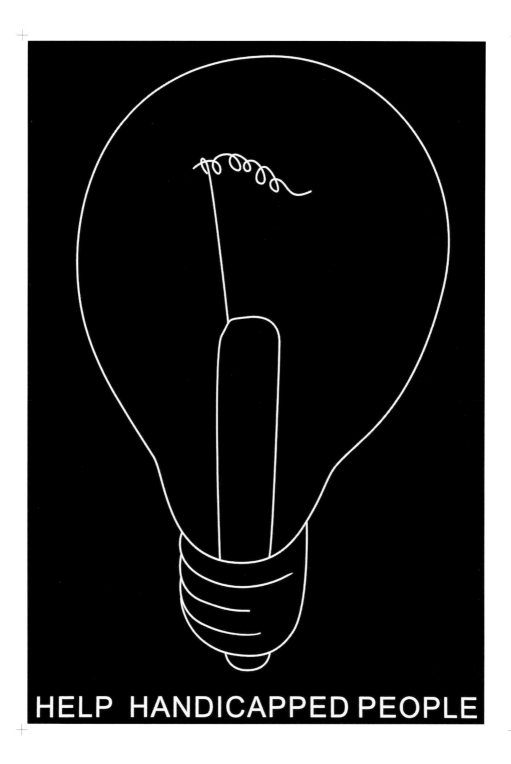

HELP HANDICAPPED PEOPLE

78 **Yang Zhen**
Help handicapped people
2002

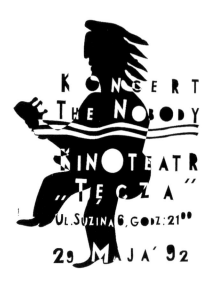

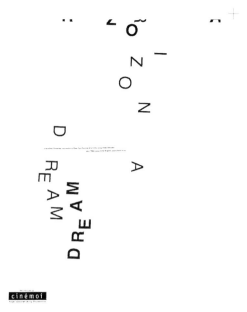

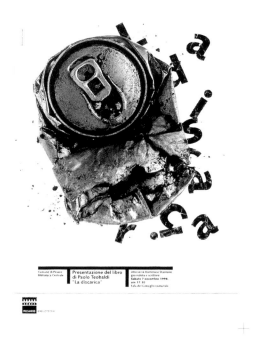

79 **Piotr Mlodozeniec**
Koncert / The Nobody
1992

80 **Toshiyasu Nanbu**
Typographic poster works of Toshiyasu Nanbu
1999

81 **Isabelle Keyeux**
Arizona dream
1996

82 **Leonardo Sonnoli**
La discarica
1998

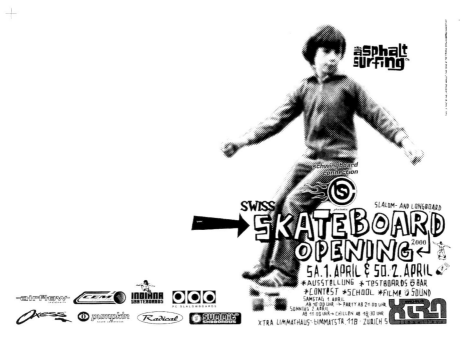

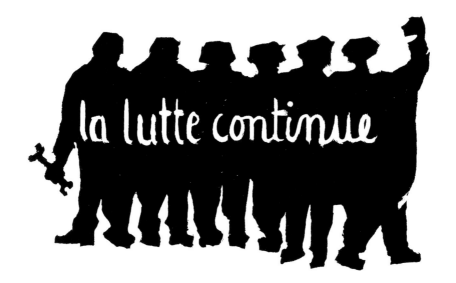

83 **Swan Lee Kampfgrafik SLK**
Swiss Skateboard Opening
2000

84 **Atelier Populaire**
La lutte continue
1968

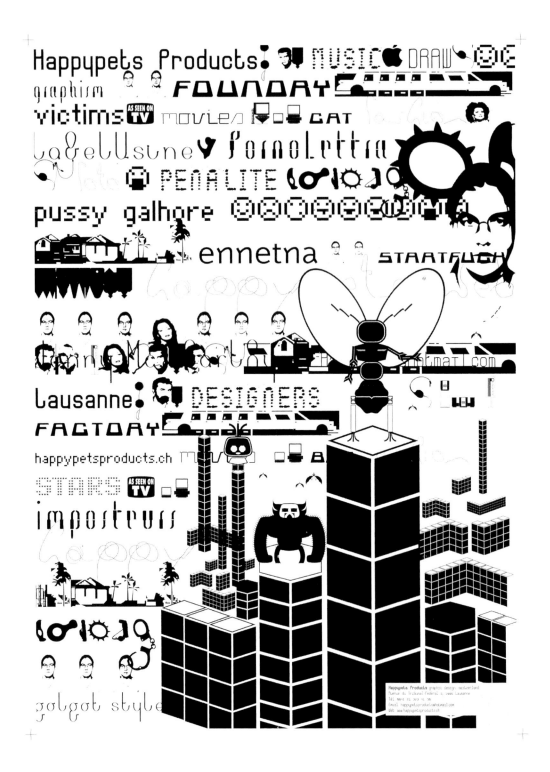

85 **Happypets Products**
Happypets Products
2000

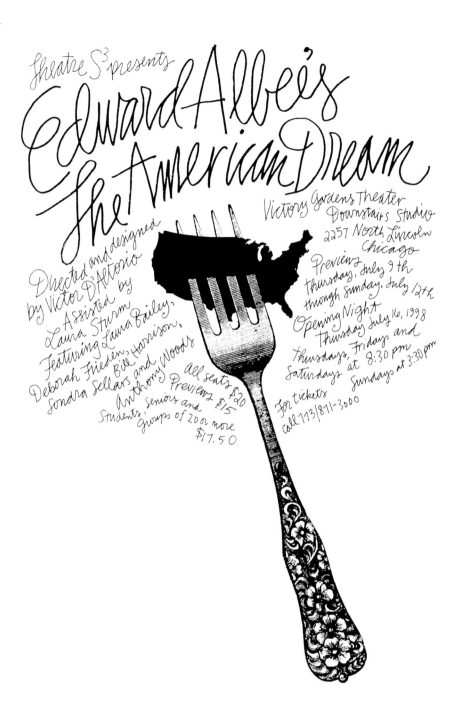

Theatre S³ presents Edward Albee's The American Dream

Victory Gardens Theater Downstairs Studio 2257 North Lincoln Chicago

Directed and designed by Victor D'Altorio Assisted by Laura Sturm Featuring Laura Bailey, Deborah Frieden, Bill Harrison, Sondra Sellars and Anthony Woods

Previews Thursday, July 9th through Sunday, July 12th

Opening Night Thursday July 16, 1998

Thursdays, Fridays and Saturdays at 8:30 pm Sundays at 3:30 pm

For tickets call 773/871-3000

All seats $20 Previews $15 Students, Seniors and groups of 20 or more $17.50

86 **Michael Bierut**
Theatre S 3 presents Edward Albee's
The American Dream
1998

87 **Marc Philipp, Andréa Muheim**
Typografie beeinflusst die Aussage eines Textes
Typography affects the statement made by a text
1994

LastLebkuch
en.EineSozialük
ungmitThorsten
Nolting2bis5Ja
uar,17bis20Uhr
LaborfürSoziale
undÄsthetische
EntwicklungBer
gerKirche,Wallst
rasseEinlassdur
chdasFenster

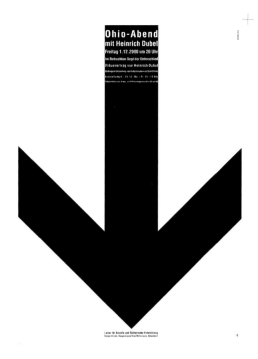

1. Reihe: **Seltene Platten**
Samstags 14 Uhr
19.2.2000 Bruce Haak, The Electric Luzifer, 1968 Moog Sounds
26.2.2000 Silver Apples Spectrum, Spaceman 3

Labor für Soziale und Ästhetische Entwicklung
Berger Kirche, Bergerstrasse Ecke Wallstrasse, Düsseldorf
In Zusammenarbeit mit Hitsville

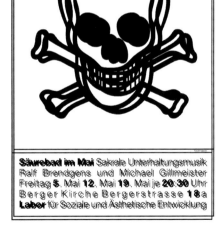

88 **Fons Matthias Hickmann**
Last Lebkuchen
2001

89 **Fons Matthias Hickmann**
1. Reihe: Seltene Platten
2000

90 **Fons Matthias Hickmann**
Ohio-Abend mit Heinrich Dubel
2000

91 **Fons Matthias Hickmann**
Säurebad im Mai
2000

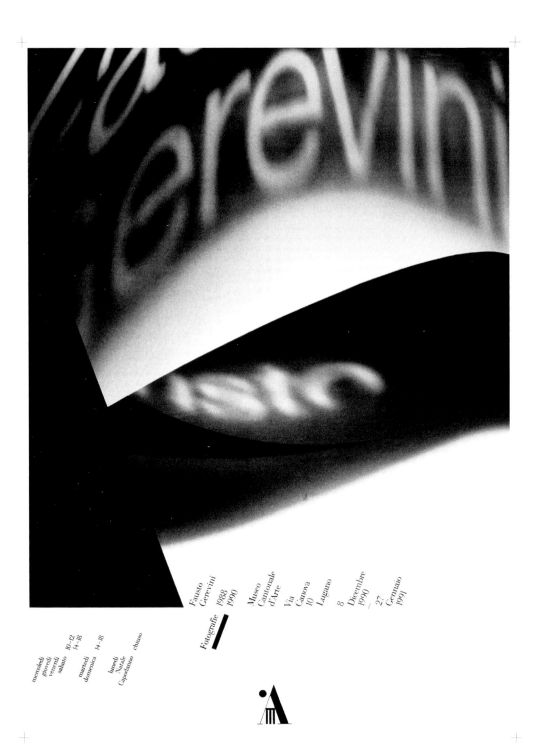

92 **Bruno Monguzzi**
Fausto Gerevini
1990

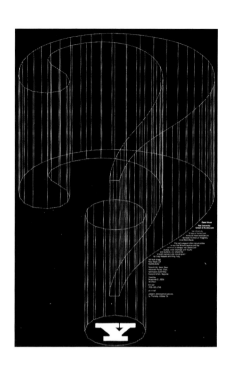

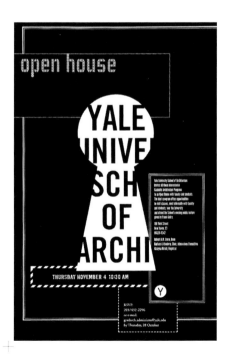

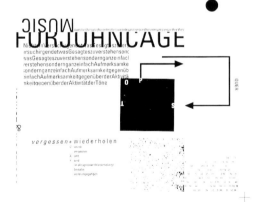

93 **Michael Bierut**
Next cities: paradoxes of postmillennial urbanism
2000

94 **Michael Bierut**
Open house / Yale University School of Architecture
1999

95 **Michael Bierut**
Open house / Yale University School of Architecture
2000

96 **Tobias Contin-Strebel**
Music for John Cage
1993

FONTANA GALLERIA LA POLENA GENOVA 1-28 OTTOBRE 1966

arte e scienza

7-14 settembre 1969
la Biennale di Venezia
32° festival internazionale di musica contemporanea

97 **AG Fronzoni**
Fontana Galleria La Polena Genova
1966

98 **AG Fronzoni**
Arte e scienza
1979

99 **AG Fronzoni**
Inascoltabili frammenti / sonori
1981

100 **AG Fronzoni**
La Biennale di Venezia
1969

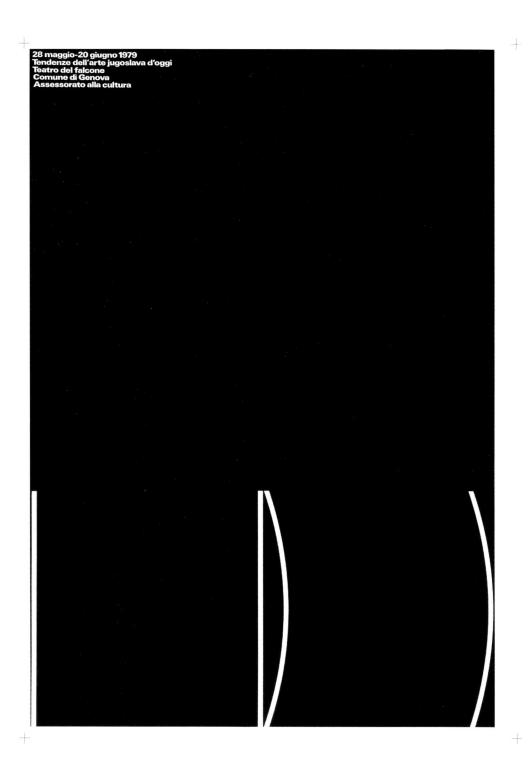

28 maggio-20 giugno 1979
Tendenze dell'arte jugoslava d'oggi
Teatro del falcone
Comune di Genova
Assessorato alla cultura

101 **AG Fronzoni**
Tendenze dell'arte yugoslava d'oggi
1979

ZANG! TUM BTUMB

IF YOU WANT IT

Tuuumb! Tuuuum Tuuuum Tuuuum

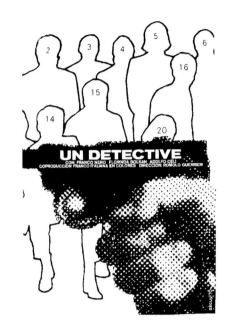

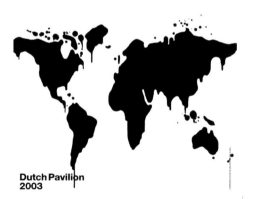

We Are
The World.

**Carlos Amorales
Alicia Framis
Meschac Gaba
Jeanne van Heeswijk
Erik van Lieshout**

**Biennale
di Venezia**

**Dutch Pavilion
2003**

102 **Experimental Jetset**
Zang! Tum Btum / If you want it
2003

103 **David Tartakover**
«Mother», 1989

104 **René Azcuy Cárdenas**
Un detective
1970

105 **Experimental Jetset**
We are the world. / Biennale di Venezia
2003

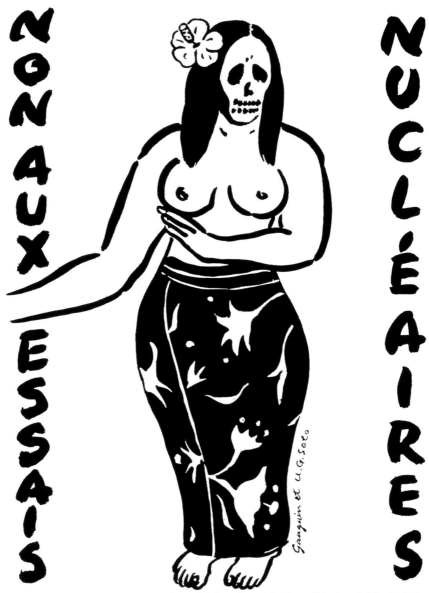

image réalisée par l'association de graphistes japonais " Jagda ", 1995

106 **U.G. Sato**
Non aux essais nucléaires
1995

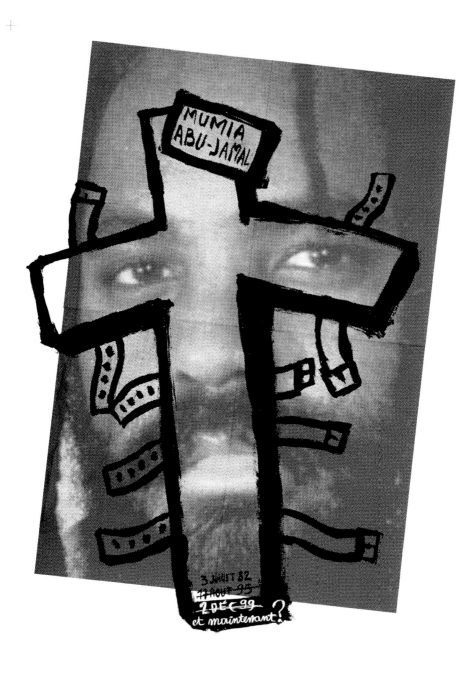

107 **Jean-Claude Blanchard**
Mumia Abu-Jamal
1999

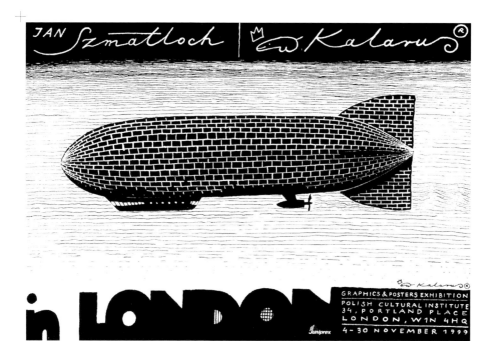

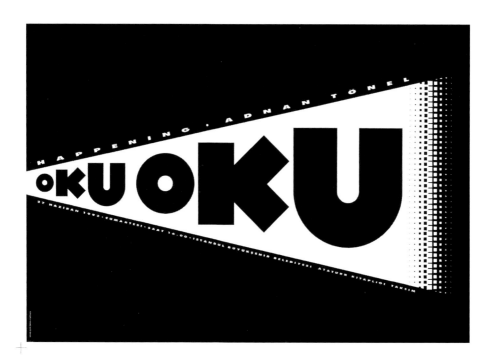

108 **Roman Kalarus**
Jan Szmatloch / Kalarus / in London
1999

109 **Savas Cekic, Sahin Aymergen**
Oku oku
1992

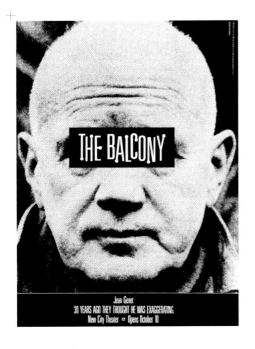

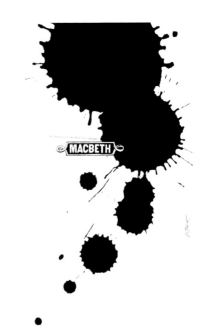

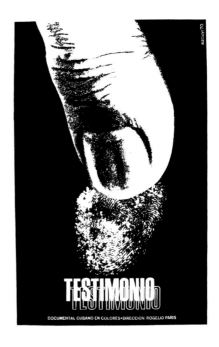

110 **Art Chantry**
The Balcony
ca. 1987

111 **Polly Bertram, Daniel Volkart**
Die Oper vom grossen Hohngelächter
The Great Mocking Laughter Opera, 1984

112 **James Victore**
The Shakespeare Project presents Macbeth
1995

113 **René Azcuy Cárdenas**
Testimonio
1971

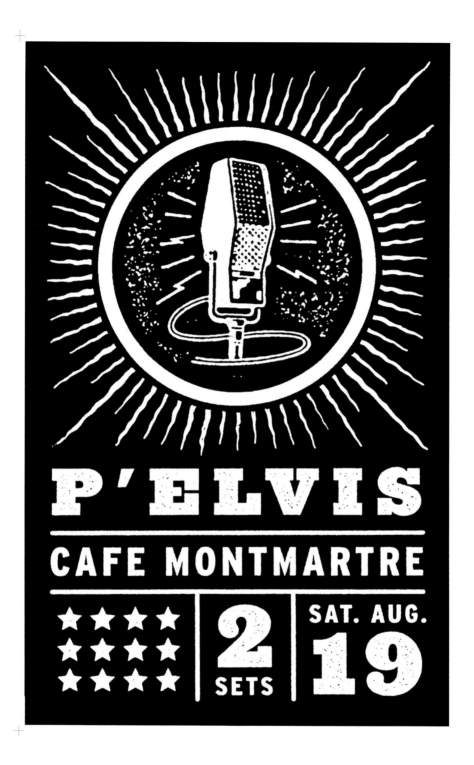

114 **Planet Propaganda**
P'Elvis/Café Montmartre

115 **AG Fronzoni**
Tania Mouraud
1970

Katalog

Alle abgebildeten Plakate stammen aus der Plakat-
sammlung des Museums für Gestaltung Zürich.

Die Daten des Katalogs folgen den Rubriken Gestal-
tung, Plakattext, Erscheinungsjahr, Erscheinungsland,
Drucktechnik und Format. Dabei gelten folgende
Regelungen:

Gestaltung: Es werden der vollständige Name und die
Lebensdaten angegeben.

Plakattext: Die beste Textwiedergabe bildet die
Abbildung des Plakates selbst. Darum wird hier eine
vereinfachte Form wiedergegeben, welche nur die
aussagekräftigen Textbestandteile berücksichtigt. All-
fällige Umstellungen dienen der Verständlichkeit. Das
Zeichen/trennt inhaltliche Texteinheiten.

Erscheinungsland: Das Erscheinungsland wird mit dem
international gebräuchlichen ISO-Code angegeben.

Drucktechnik: Die englische Übersetzung der Druck-
technik erschliesst sich meist aus dem deutschen
Begriff wie Lithografie oder Offset.

Format: Die Angaben werden in der Abfolge Höhe ×
Breite und in cm gemacht. Weil die Plakate oft nicht
exakt rechtwinklig geschnitten sind, werden die Abmes-
sungen auf halbe cm aufgerundet.

Die Plakatgeschichte ist ein junges Forschungsgebiet –
verlässliche Hinweise sind rar. Jeder Hinweis und jede
Ergänzung sind willkommen:
Plakatsammlung@museum-gestatung.ch

Catalogue

The posters illustrated come from the Museum für
Gestaltung Zürich's Poster Collection.

The data in the catalogue are under the headings
poster text, year of appearance, country of first appea-
rance, printing technique, format. The following rules
have been applied:

Design: the full name and dates of birth and the present
base for activities are given.

Poster text: the poster itself provides the best version
of the text. Thus a simplified form is used here, giving
only the most meaningful elements of the text. Any
rearrangements that have been made are for purposes
of intelligibility. The sign/separates textual units
by content.

Country of first appearance: The country in which the
poster appeared is identified by the internationally
accepted ISO code.

Printing technique: the English translation of the
printing technique is usually suggested by the German
concept, as in Lithografie or Offset. Buchdruck means
letterpress, Linolschnitt means lino cut.

Format: the details are given in the sequence
height × width and in cm. Because the posters are
often not cut exactly at right angles, the dimensions
are rounded off to half cm.

The history of posters is a recent field of research –
reliable information is rare. Any references or additional
material are welcome:
plakat.sammlung@museum-gestaltung.ch

1 James Victore (*1962)
Richard III
1994
US Siebdruck 91,5 × 61

2 Melchior Imboden (*1956)
Kunstmarkt / Innerschweizer
Künstler in der Schmiedgasse
Stans / Art market / Central Swiss
artists in Schmiedgasse, Stans
1991
CH Siebdruck 128 × 90,5

3 Werner Jeker (*1944)
René Burri / One world
1985
CH Siebdruck 128 × 90,5

4 Pierre Mendell Design Studio
Pierre Mendell (*1929)
Markus Frank (*1969)
Die Angestellten / Eine Ausstellung
/ The employees / An exhibition /
Münchner Stadtmuseum
1995
DE Offset 119 × 84

5 AG Fronzoni (1923–2002)
Istituto statale d'arte / Monza
1970
IT Siebdruck 99,5 × 69

6 Luba Lukova (*1960)
Sudan
1999
US Siebdruck 100 × 69,5

7 Han Jiaying (*1961)
Frontiers
1999
CN Siebdruck 100 × 70

8 Vince Frost (*1964)
Vince Frost / CSD Voicebox lectures
1999
GB Siebdruck 101 x 73

9 Bülent Erkmen (*1947)
10 artists 10 works: A
1988
TR Siebdruck 88 × 61,5

10 AG Fronzoni (1923–2002)
Sonia Delaunay / Galleria de
Nieubourg
1968
IT Siebdruck 65,6 × 47,5

11 Almir Mavignier (*1925)
Mavignier /
Museum Ulm Kunstverein
1986
DE Siebdruck 84 × 60

12 Ralph Schraivogel (*1960)
B-4 / Serigraphie Uldri
1992
CH Siebdruck 128 × 90,5

13 Niklaus Troxler (*1947)
Gaube Liebe Hoffnung von Ödön
von Horvath / Faith Love Hope
by Ödön von Horvath /
Theatergesellschaft Willisau
1992
CH Siebdruck 128 × 90,5

14 Armin Hofmann (*1920)
Die gute Form / Good Design /
SWB-Sonderschau / Mustermesse
Basel
1954
CH Offset 128 × 90,5

15 Armin Hofmann (*1920)
Fotografie / photograph:
Paul Merkle
Stadttheater Basel
1960
CH Offset 127 × 90

16 Woody Pirtle (*1944)
The letter «Y» designed by
Woody Pirtle
1994
US Siebdruck 89 × 58,5

17 Dolcini Associati
Leonardo Sonnoli (*1962)
A / Pesaro e l'archeologia
1998
IT Offset 100 × 70

18 Emil Ruder (1914–1970)
Z / Die Zeitung / The newspaper
1958
CH Hochdruck 127 × 90

19–27 M/M (Paris)
Michael Amzalag (*1968),
Mathias Augustyniak (*1967)
[The Alphabet / Ann-Catherine,
Bridget, Carmen Maria, Frankie
Rayder, Stephanie Seymour,
Trish, Xeyenne, abbeY, Zoe]
2001
FR Silkscreen 120 × 176
based on original photographs
by Inez van Lamsweerde &
Vinoodh Matadin.

28 M/M (Paris)
Michael Amzalag (*1968),
Mathias Augustyniak (*1967)
[The Alphabet / Griet]
2001
FR Silkscreen 120 × 176
based on original photographs
by Inez van Lamsweerde &
Vinoodh Matadin.

29 Werner Jeker (*1944)
Aaron Siskind / Musée de l'Elysée
Lausanne
1994
CH Siebdruck 128 × 90,5

30 Werner Jeker (*1944)
Jean Otth / Musée cantonal
des beaux-arts Lausanne
1984
CH Siebdruck 128 × 90,5

31 Werner Jeker (*1944)
Mario Giacometti /
Musée de l'Elysée Lausanne
1993
CH Siebdruck 128 × 90,5

32 Dolcini Associati
Leonardo Sonnoli (*1962)
L'Oscurità trasparente /
Percorsi tra creatività e follia
1998
IT Offset 99 × 70

33 Werner Jeker (*1944)
Christa de Carouge / Vêtements
réinventés / Musée des arts
décoratifs Lausanne
1993
CH Siebdruck 128 × 90,5

34 Werner Jeker (*1944)
Donigan Cumming / Musée de
l'Elysée Lausanne
1996
CH Siebdruck 128 × 90,5

35 Peter Felder (*1960)
Foto: Georg Alfare
Amor mio
1997
AT Siebdruck, Klarlackaufdruck
84 × 59

36 Bruno Monguzzi (*1941)
Video Art / Il tempo / La luce / La
Materia / Museo Cantonale d'Arte
Lugano
1996
CH Siebdruck 128 × 90,5

37 Sandstrom Design Inc.
Steve Sandstrom (*1955)
Get a new perspective on
the world / The 23rd Portland
International Filmfestival
2000
US Offset 101 × 66

38 Werner Jeker (*1944)
Ugo Mulas (1928–1978) /
Musée de l'Elysée Lausanne
1986
CH Siebdruck 128 × 90,5

39 Naoki Hirai (*1960)
Peace
2000
JP Offset 103 × 73

40 Ralph Schraivogel (*1960)
Gross und Klein / Museum für
Gestaltung Zürich
Large and small
1997
CH Siebdruck 128 × 90,5

41 Fons Matthias Hickmann
(*1966)
80 Jahre Joseph Beuys /
80 years of Joseph Beuys
2001
DE Siebdruck 84 × 60

42 Studio Dumbar
Catherine van der Eerden (*1963)
Fotografie / photograph: Leo van
der Noort
Massage / Theater aan het Spui
Den Haag / Het Nationale Toneel
1996
NL Siebdruck 59 × 41,5

43 Bob Vinteller (*1970)
Her street Act / 312 Sections /
Damaged & Painful Productions
2001
GB Xerox 119 × 82

44 Fons Matthias Hickmann
(*1966)
Die Toten / Eine Ausstellung von
Hans-Peter Feldmann /
The dead / An exhibition by
Hans-Peter Feldmann
2001
DE Offset 84 × 60

45/46 Uwe Loesch (*1943)
Gunnar Fiel (*1967)
Museum für Gegenwartskunst
Siegen / Eröffnung 6. Mai 2001 /
Opening 6. Mai 2001
2001
DE Siebdruck 119 × 84

47 Yoshiteru Asai (*1940)
Bequeath beautiful environment
and lives. We must continue to
talk about the tragic accident to
the next generation.
1987
JP Offset 73 × 103

48 Suric Design
Jurij Surkov (*1961)
Idea
2000
RU Siebdruck 98 × 68

49 Alejandro Magallanes (*1971)
Proyecto Goya Posada
2002
MX Siebdruck 95 × 70

50 Xiaoming Zhang (*1974)
Co-operation
2001
CN Siebdruck 90 × 63

51 James Victore (*1962)
Romeo Juliet
1993
US Siebdruck 86,5 × 61

52 Nous travaillons ensemble /
Grapus / On va gagner!
1991
FR Offset 80 × 60

53 Roman Kalarus (*1951)
Wobec Wartosci / Muzeum
Diecezjalne
1986
PL Siebdruck 83 × 58

54 Naoya Murata (*1968)
One color message /
Naoya Murata one color posters
exhibition
1995
JP Siebdruck 103 × 73

55 Pierre Mendell Design Studio
Pierre Mendell (*1929)
Heinz Hiltbrunner (*1955)
Münchner Volkshochschule
2001
DE Offset 119 × 84

56 Naoki Hirai (*1960)
Save the water
2002
JP Offset 103 × 73

57 Naoya Murata (*1968)
Naoya Murata posters exhibition
«one color message».
1995
JP Siebdruck 103 × 73

58 Gunter Rambow (*1938)
Linie 1 / Hessisches Staatstheater
Wiesbaden
1998
DE Siebdruck 164 × 116,5

59 Rio Grafik
Nina Mambourg (*1971)
Corinne Hächler (*1970)
Nils Wogram & Root 70
2000
CH Siebdruck 59,5 × 42

60 Art Chantry (*1954)
The Monomen on tour
1993
US Siebdruck 74 × 59

61 Meister
Howl / Concert by Allen Ginsberg
ca. 1979
CH Xerox 58 × 42

62 anonym
Sperma / Out now 12" single
1979
CH Offset 61 × 42

63 Tschumi, Küng
Emanuel Tschumi (*1964)
Max Küng (*1969)
Das Beste aus: Menschliches
Versagen / The best of:
Human error / Theater Basel
1998
CH Siebdruck 60 × 42

64 Ryuichi Yamashiro (*1920)
Hayashi / Mori
1955
JP Siebdruck 100,5 × 73,5

65 Toshiyasu Nanbu (*1951)
Shanghai-Osaka Design 2000
2000
JP Offset 103 × 73

66 Taku Satoh Design Office Inc.
Taku Satoh (*1955)
Rebuild / Taku Satoh Design Office
1992
JP Offset 103 × 73

67 Yoshiteru Asai (*1940)
Migrating Birds... A cloud happens
to move across the sun
1994
JP Siebdruck 103 × 73

68 Han Jiaying (*1961)
Frontiers
2001
CN Siebdruck 100 × 70

69 Siu Hong Freeman Lau (*1958)
People
2000
CN Siebdruck 99,5 × 70

70 Tai-Keung Kan (*1942)
Paul Rand
1997
CN Siebdruck 51,5 × 46

71 Siu Hong Freeman Lau (*1958)
People
2000
CN Siebdruck 99,5 × 70

72 Tai-Keung Kan (*1942)
Unification / North Korea / South
Korea
1997
CN Siebdruck 99,5 × 71

73 Tai-Keung Kan (*1942)
Foto: C.K. Wong
Celebrating the New Born of the
Museum of Design
1999
CN Siebdruck 97,5 × 69

74 Hung Lam (*1973)
Foto: Bobby Lee
Life
2001
JP Offset 103 × 72,5

75/76 Shinnoske Sugisaki
(*1953)
Morisawa Font
1997
JP Offset/Siebdruck 103 × 146

77 Han Jiaying (*1961)
Frontiers
1999
CN Siebdruck 100 × 70

78 Yang Zhen (*1973)
Help handicapped people
2002
CN Siebdruck 84 × 57

79 Piotr Mlodozeniec (*1956)
Koncert/The Nobody/Kinoteatr
Tecza
1992
PL Siebdruck 100 × 70

80 Toshiyasu Nanbu (*1951)
Typographic poster works of
Toshiyasu Nanbu
1999
JP Offset 103 × 73

81 Isabelle Keyeux (*1974)
Arizona dream/Cinémoi
1996
BE Xerox 83,5 × 59

82 Dolcini Associati
Leonardo Sonnoli (*1962)
La discarica/Presentazione
del libro di Paolo Teobaldi
«La Discarica»
1998
IT Offset 100 × 69

83 Swan Lee Kampfgrafik SLK
Jan Indermühle (*1969)
Swiss Skateboard Opening/
Slalom and Longboard
2000
CH Offset 42 × 59,5

84 Atelier Populaire
La lutte continue
1968
FR Linoldruck 28 × 44

85 Happypets Products
Violène Pont (*1974)
Patrick Monnier (*1974)
Cédric Henny (*1972)
Happypets Products
(Plakat und Faltprospekt)
2000
CH Offset 62 × 45

86 Pentagram Design New York
Michael Bierut (*1957)
Theatre S 3 presents Edward
Albee's The American Dream
1998
US Siebdruck 91 × 61,5

87 Marc Philipp (*1962)
Andréa Muheim (Geb.datum)
Typografie beeinflusst die
Aussage eines Textes/
Typography affects the statement
made by a text
1994
CH Siebdruck 127 × 90,5

88 Fons Matthias Hickmann
(*1966)
Last Lebkuchen/Eine Sozialübung
mit Thorsten Nolting/Load
gingerbread/A social exercise
with Thorsten Nolting/
Labor für Soziale und Ästhetische
Entwicklung
2001
DE Siebdruck 84 × 60

89 Fons Matthias Hickmann
(*1966)
1.Reihe: Seltene Platten/
1st series: Rare records/
Labor für Soziale und Ästhetische
Entwicklung
2000
DE Siebdruck 84 × 60

90 Fons Matthias Hickmann
(*1966)
Ohio-Abend mit Heinrich Dubel/
Ohio evening with Heinrich Dubel/
Labor für Soziale und Ästhetische
Entwicklung
2000
DE Siebdruck 84 × 60

91 Fons Matthias Hickmann
(*1966)
Säurebad im Mai/Sakrale Unter-
haltungsmusik/Acid bath in May/
Sacred light music/
Labor für Soziale und Ästhetische
Entwicklung
2000
DE Siebdruck 84 × 60

92 Bruno Monguzzi (*1941)
Fausto Gerevini/Museo Catonale
d'Arte Lugano
1990
CH Offset 128 × 90,5

93 Pentagram Design New York
Michael Bierut (*1957)
Next cities: paradoxes of post-
millennial urbanism/Yale School
of Architecture
2000
US Offset 86 × 56

94 Pentagram Design New York
Michael Bierut (*1957)
Open house/Yale University
School of Architecture
1999
US Siebdruck 86,5 × 56

95 Pentagram Design New York
Michael Bierut (*1957)
Open house/Yale University
School of Architecture
2000
US Siebdruck 86,5 × 56

96 Tobias Contin-Strebel (*1965)
Music for John Cage
(faltbarer Plakatbogen, beidseitig
bedruckt)
1993
CH Siebdruck 84 × 58

97 AG Fronzoni (1923–2002)
Fontana Galleria La Polena Genova
1966
IT Siebdruck 99 × 70

98 AG Fronzoni (1923–2002)
Arte e scienza
1979
IT Siebdruck 96 × 68

99 AG Fronzoni (1923–2002)
Inascoltabili frammenti/sonori
1981
IT Siebdruck 98,5 × 68,5

100 AG Fronzoni (1923–2002)
La Biennale di Venezia/
32. festival internazionale di
musica contemporanea
1969
IT Siebdruck 69,5 × 100

101 AG Fronzoni (1923–2002)
Tendenze dell'arte yugoslava
d'oggi
1979
IT Siebdruck 98 × 76

102 Experimental Jetset
Marieke Stolk (*1967)
Danny van den Dungen (*1971)
Erwin Brinkers (*1973)
Zang! Tum Btum/If you want it
2003
IT Siebdruck 100 × 70

103 David Tartakover (*1944)
Foto: Reuters
«Mother»
1989
IL Offset 84 × 59,5

104 René Azcuy Cárdenas
(*1939)
Un detective
1970
CU Siebdruck 76 × 51

105 Experimental Jetset
Marieke Stolk (*1967)
Danny van den Dungen (*1971)
Erwin Brinkers (*1973)
We are the world./Biennale di
Venezia/Dutch Pavillon 2003
2003
IT Siebdruck 100 × 70

106 U.G. Sato (*1935)
Non aux essais nucléaires/
Gauguin et U.G. Sato
1995
JP Siebdruck 175 × 118

107 Jean-Claude Blanchard
(*1945)
Mumia Abu-Jamal
1999
FR Siebdruck 102 × 67

108 Roman Kalarus (*1951)
Jan Szmatloch/Kalarus/
in London
1999
PL Siebdruck 68 x 98

109 Savas Cekic (*1960)
Sahin Aymergen (*1961)
Oku oku/Happening. Adnan
Tönel
1992
TR Offset 45 × 65

110 Art Chantry (*1954)
The Balcony/Jean Genet/
New City Theater
ca. 1987
US Siebdruck 61 × 45

111 Polly Bertram (*1953)
Daniel Volkart (*1959)
Theater am Neumarkt/Die Oper
vom grossen Hohngelächter/The
Great Mocking Laughter Opera
1984
CH Siebdruck 128 × 90,5

112 James Victore (*1962)
The Shakespeare Project presents
Macbeth
1995
US Siebdruck 85,5 × 57,5

113 René Azcuy Cárdenas
(*1939)
Testimonio/Documental cubano
en colores
1971
CU Siebdruck 76 × 50,5

114 Planet Propaganda
Kevin Wade (*1963)
Michael Byzewski (*1974)
P'Elvis/Café Montmartre
US Siebdruck 56 × 35,5

115 AG Fronzoni (1923–2002)
Tania Mouraud/Centro Apollinaire
Milano
1970
IT Offset 68 × 48,5

Lars Müller
Geboren 1955 in Oslo, Norwegen.
Gestalter AGI und Verleger.
Lebt in Baden, Schweiz.

Lars Müller
Born in Oslo, Norway in 1955.
Graphic Designer AGI and Publisher.
Lives in Baden, Switzerland.

Dank
Publikations- und Ausstellungsprojekte für die Plakat-
sammlung sind jeweils willkommener Anlass, den
eigenen umfangreichen Bestand themenspezifisch zu
sichten und aufzuarbeiten, aber auch durch gezielte
Akquisitionen zu aktualisieren. Für die vorliegende
Publikation haben wir zahlreiche Plakate von Gestalter-
innen und Gestaltern erhalten. Ohne ihre grosszügigen
Zusendungen wäre der zeitgenössische Fokus der
vorliegenden Auswahl an schwarz-weissen Plakaten
nicht möglich gewesen.
Wir danken allen ganz herzlich, die die Plakatsammlung
mit ihren eigenen Arbeiten, wertvollen Informationen
und theoretischen Auseinandersetzungen zum Phäno-
men Schwarz-Weiss bereichert haben.

Thanks
Publication and exhibition projects are always welcome
occasions for the Poster Collection to look at and
review its own considerable holdings in terms of a
specific theme, but also to update them with relevant
acquisitions. We have received large numbers of
posters from designers for the present publication. The
contemporary focus in the present collection of
black-and-white posters would not have been possible
without their generous contributions.
We offer our warmest thanks to everyone who has
enriched the Poster Collection with their own work,
valuable information and theoretical analysis of the
black-and-white phenomenon.

Umschlag
Das Umschlagbild ist dem Plakat *Team Colore* (1973)
vom AG Fronzoni nachempfunden. Im Gegensatz zu
allen anderen Plakaten dieser Publikation befindet es
sich nich in der Plakatsammlung des Museums für
Gestaltung.

Cover
The cover picture is modelled on AG Fronzoni's poster
Team Colore (1973). Unlike all the other posters in
this publication, it is not in the Museum für Gestaltung's
Poster Collection.

«Poster Collection»
Herausgegeben von / Published by
Felix Studinka
Kurator der Plakatsammlung /
Curator of the Poster Collection
Museum für Gestaltung Zürich
In Zusammenarbeit mit / in cooperation with
Bettina Richter, Wissenschaftliche Mitarbeiterin /
Scientific collaborator
Christina Reble, Publikationen / Publications
Museum für Gestaltung Zürich

Schwarz und Weiss / Black and White
Konzept, Redaktion / Concept, Editing:
Lars Müller, Bettina Richter
Lektorat / Sub-editing: Christina Reble
Übersetzung / Translation: Michael Robinson
Gestaltung / Design:
Integral Lars Müller / Hendrik Schwantes
Assistenz / Assistance: Gisèle Schindler
Lithografie / Repro: Ast & Jakob AG, Köniz
Druck / Printing: Vetsch + Co AG, Köniz
Einband / Binding: Buchbinderei Burkhardt AG,
Mönchaltorf

© 2003
Hochschule für Gestaltung und Kunst Zürich,
Zürcher Fachhochschule & Lars Müller Publishers

Museum für Gestaltung Zürich
Plakatsammlung / Poster Collection
Limmatstrasse 57
CH-8005 Zürich / Switzerland
e-mail: plakat.sammlung@museum-gestaltung.ch
http://www.museum-gestaltung.ch

Lars Müller Publishers
CH-5401 Baden / Switzerland
e-mail: books@lars-muller.ch
http://www.lars-muller-publishers.com

ISBN 3-03778-014-2
Erste Auflage / First Edition 2003

Printed in Switzerland